2000

Alphonse

Mucha

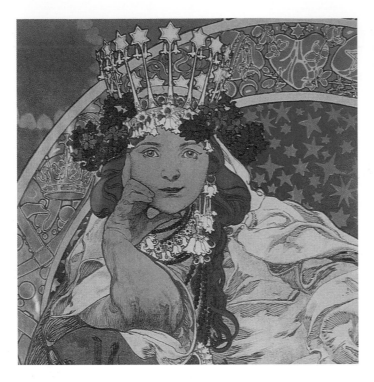

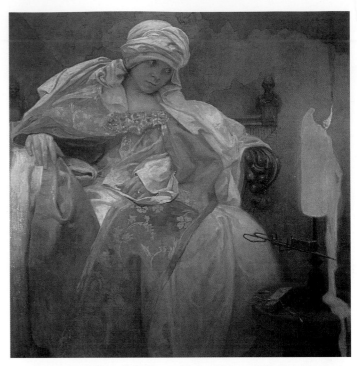

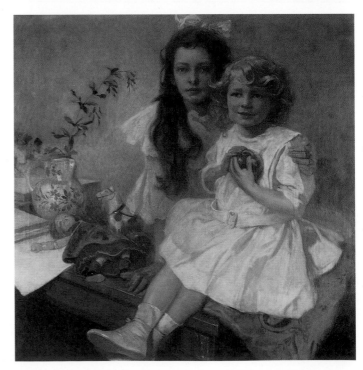

Text: Patrick Bade

© 2005 Sirrocco, London, UK (English version)

© 2005 Confidential Concepts, worldwide, USA

© 2005 Estate Mucha / Artists Rights Society, New York, USA / ADAGP, Paris

ISBN 1-84013-767-3

Published in 2005 by Grange Books

an imprint of Grange Book Plc

The Grange Kingsnorth Industrial Estate

Hoo, nr Rochester, Kent ME3 9ND

www.Grangebooks.co.uk

Printed in China

Alphonse Mucha

Grange
BOOKS

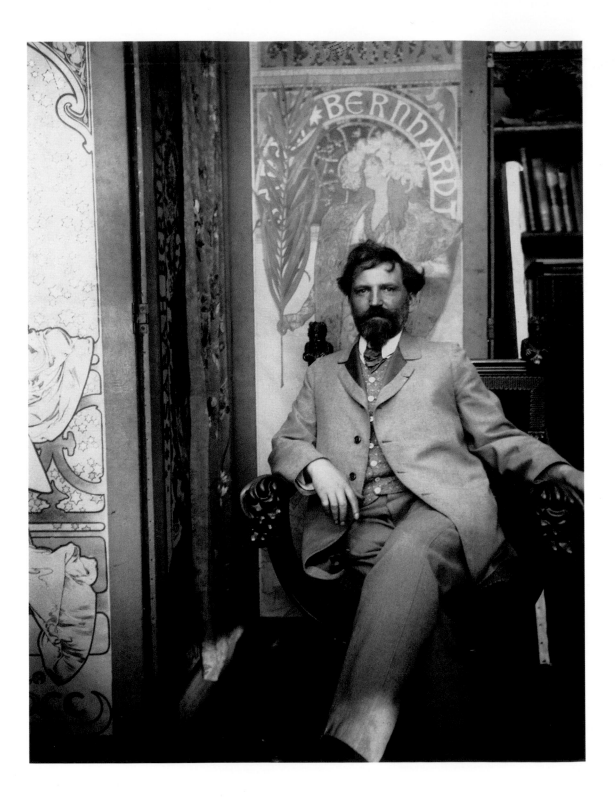

Since the Art Nouveau revival of the 1960s, when students around the world adorned their rooms with reproductions of Mucha posters of girls with tendril-like hair and the designers of record sleeves produced Mucha imitations in hallucinogenic colours, Alphonse Mucha's name has been irrevocably associated with the Art Nouveau style and with the Parisian fin-de-siècle. Artists rarely like to be categorised and Mucha would have resented the fact that he is almost exclusively remembered for a phase of his art that lasted barely ten years and that he was regarded as of lesser importance. As a passionate Czech patriot he would have also been unhappy to be regarded as a "Parisian" artist.

Mucha was born on July 14, 1860 at Ivančice in Moravia, then a province of the vast Habsburg Empire. It was an empire that was already splitting apart at the seams under the pressures of the burgeoning nationalism of its multi-ethnic component parts. In the year before Mucha's birth, nationalist aspirations throughout the Habsburg Empire were encouraged by the defeat of the Austrian army in Lombardy that preceded the unification of Italy. In the first decade of Mucha's life Czech nationalism found expression in the orchestral tone poems of Bedřich Smetana that he collectively entitled "Ma Vlast" (My country) and in his great epic opera "Dalibor" (1868). It was symptomatic of the Czech nationalist struggle against the German cultural domination of Central Europe that the text of "Dalibor" had to be written in German and translated into Czech. From his earliest days Mucha would have imbibed the heady and fervent atmosphere of Slav nationalism that pervades "Dalibor" and Smetana's subsequent pageant of Czech history "Libuse" which was used to open the Czech National Theatre in 1881 and for which Mucha himself would later provide set and costume designs.

Mucha's upbringing was in relatively humble circumstances, as the son of a court usher. His own son Jiři Mucha would later proudly trace the presence of the Mucha family in the town of Ivančice back to the fifteenth century. If his family was poor, Mucha's upbringing was nevertheless not without artistic stimulation and encouragement. According to his son Jiři "He drew even before he learnt to walk and his mother would tie a pencil round his neck with a coloured ribbon so that he could draw as he crawled on the floor. Each time he lost the pencil, he would start howling." His first important aesthetic experience would have been in the Baroque church of St. Peter in the local capital of Brno where from the age of ten he sang as a choir-boy in order to support his studies in the grammar school. During his four years as a chorister he came into frequent contact with the six years older Leoš Janáček, the greatest Czech composer of his generation with whom he shared a passion to create a characteristically Czech art.

1. Mucha in his studio, rue du Val-de-Grâce, Paris, c. 1898.

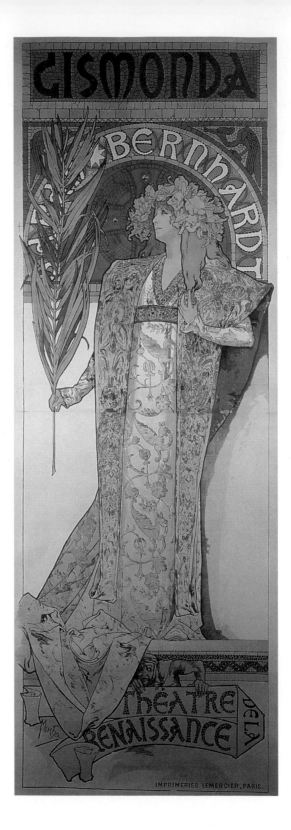

2. *Gismonda,* 1894.
 Coloured Lithograph,
 74.2 x 216 cm.
 Mucha Museum, Prague.

3. *Zodiac,* 1896.
 Coloured Lithograph,
 48.2 x 65.7 cm.
 Mucha Museum, Prague.

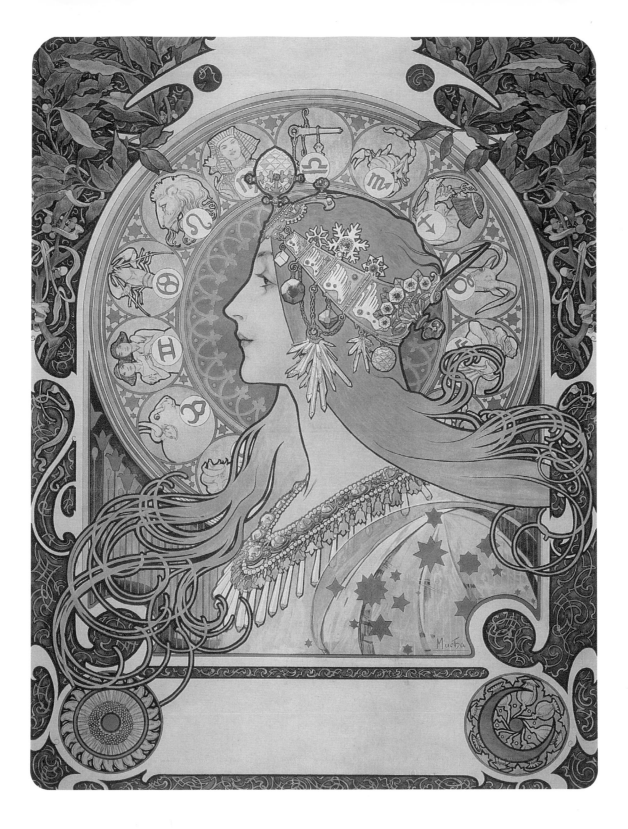

The voluptuous theatricality of Central European Baroque with its lush curvilinear and nature-inspired decoration undoubtedly coloured his imagination and inspired a taste for "smells and bells" and religious paraphernalia that remained with him. At the height of his fame, his studio was described as being like a "secular chapel… screens placed here and there, that could well be confessionals; and then incense burning all the time. It's more like the chapel of an oriental monk than a studio."

While earning a living as a clerk, Mucha continued to indulge his love of drawing and in 1877 he gathered together his self-taught efforts and attempted unsuccessfully to enter the Academy of Fine Arts in Prague. After two more years of drudgery as a civil servant, he lost his job, according to Jiři Mucha, because he drew the portraits of a picturesque family of gypsies instead of taking down their particulars. In 1879 he spotted an advertisement in a Viennese newspaper for the firm of Kautsky-Brioschi-Burghardt, makers of theatrical scenery who were looking for designers and craftsmen. Mucha sent off examples of his work and this time he was successful and received an offer of a job.

As a country boy who had been no further than the picturesque but still provincial Prague, Vienna in 1879 must have looked awesomely grand. It had recently undergone what was, after Haussmann's Paris, the most impressive scheme of urban renewal of the nineteenth century. Each of the great public buildings lining the Ringstrasse, which replaced the old ramparts that had encircled the medieval town centre, was built in a historical style, deemed appropriate to its purpose. The result was a grandiose architectural fancy-dress ball. The Art Nouveau style, of which Mucha would later become one of the most famous representatives, reacted directly against this kind of pompous wedding cake historicism. For the moment though, Mucha was deeply influenced by the showy and decorative art of Hans Mackart, the most successful Viennese painter of the Ringstrasse period.

After barely two years, Mucha's Viennese sojourn came to an abrupt end. On December 10th 1881, the Ringtheater burnt down. In a century punctuated by terrible theatre fires, this was one of the worst, claiming the lives of over five hundred members of the audience. The Ringtheater was also one of the principal clients of the firm of Kautsky-Brioschi-Burghardt and in the aftermath of the disaster, Mucha lost his job.

Mucha moved to the small town of Mikulov and fell back upon the time-honoured method for artists to keep the pot boiling, of making portraits of local dignitaries. His unusual way of attracting a clientele is related in his memoirs. He booked into the "Lion Hotel" and managed to sell a drawing of some local ruins to a dealer called Thiery who displayed it in his shop window and quickly sold it on. "So I got busy drawing again, not ruins this time but the people around me.

4. *Crucifixion*, c.1868.
Watercolour on paper,
23.5 x 37 cm.
Mucha Museum, Prague.

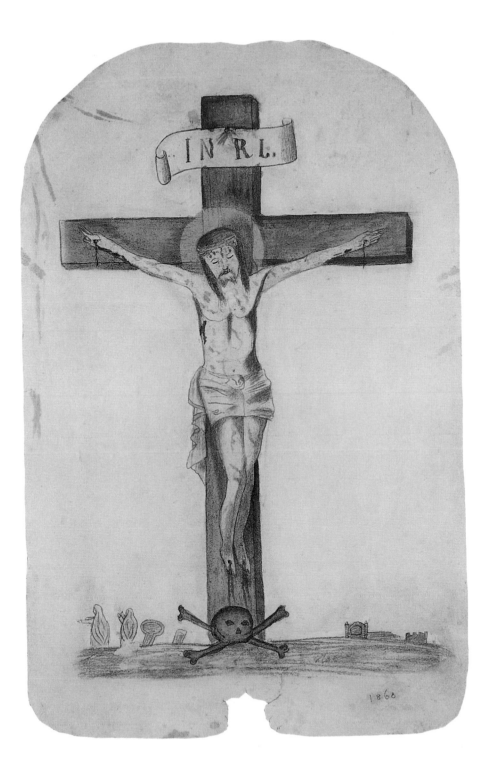

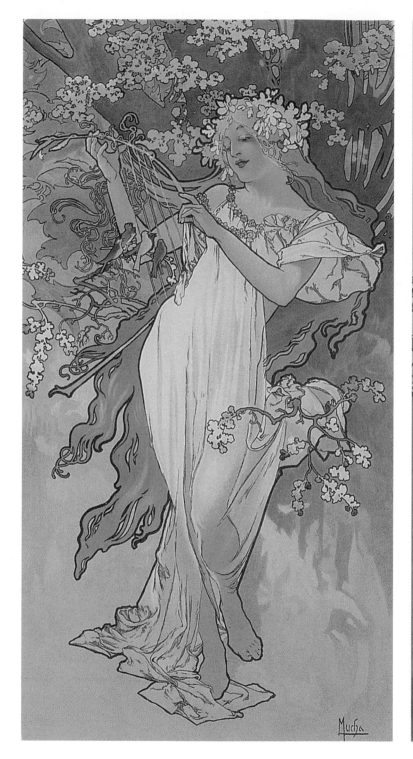

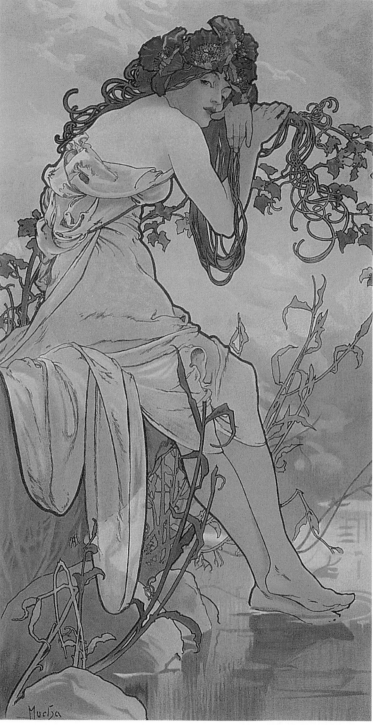

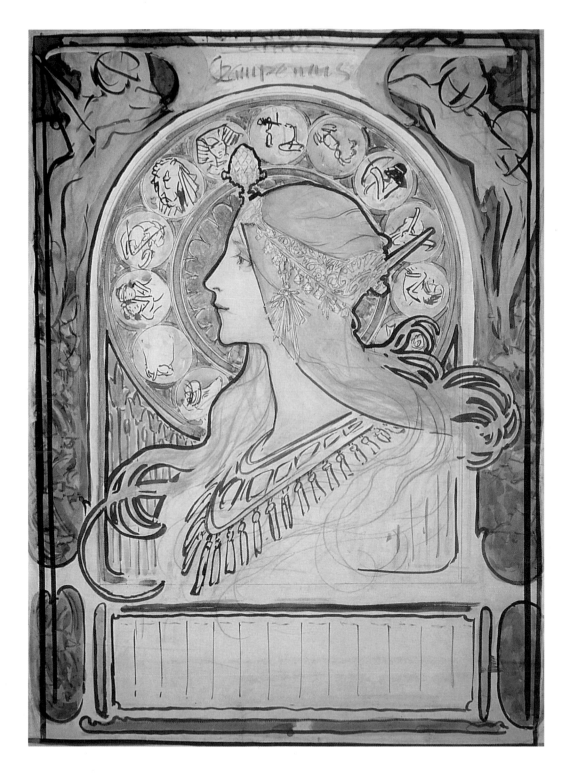

5. *Spring* (from the
 Seasons series), 1896.
 Coloured Lithograph,
 14.5 x 28 cm.
 Mucha Museum, Prague.

6. *Summer* (from the
 Seasons series), 1896.
 Coloured Lithograph,
 14.5 x 28 cm.
 Mucha Museum, Prague.

7. *Study for "Zodiac"*,
 1896. Pencil, ink and
 watercolour,
 46 x 64 cm.
 Mucha Museum, Prague.

"I painted the head of a pretty woman and brought it to Thiery. He put it into the window and I began to look forward to the cash. When there was no news from Thiery for two and even three days, I went to ask him myself. The good man wasn't pleased to see me. Mikulov society was filled with indignation, and my picture had to be taken out of the window. The young lady I had painted was the wife of the local doctor, and Thiery had put a notice next to the portrait saying, 'For five florins at the Lion Hotel'. The scandal was duly explained and in the end worked out to my advantage. The whole town knew that a painter had come to live at the Lion. In the course of time, I painted the whole neighbourhood – all the uncles and aunts of Mikulov."

It was while he was living at Mikulov that Mucha encountered the first of the two patrons who were to transform his career. This was a wealthy local landowner called Count Khuen, who invited Mucha to decorate the dining room with frescoes in the newly built castle of Emmahof near Hrušovany. This was Mucha's first encounter with murals and initiated a life-long ambition to paint large-scale decorative work. Even the posters of the 1890s on which Mucha's fame now largely rests can be seen as reflecting this desire to decorate walls. Such a desire was common to many artists of the fin-de-siècle. The large scale decorative paintings of Pierre Puvis de Chavannes, the most widely admired and influential artist of the period, were commonly referred to as "fresques" though they were in fact oil paintings on canvas that simulated the effect of frescoes. The manifesto of the Symbolist "Salon de la Rose + Croix" set up in 1892 by "Sar" Joséphin Péladan, stated "The Order prefers work which has a mural-like character as being of superior essence". The paintings of Edvard Munch's "Frieze of Life" and the flat stylised canvases of Gauguin could be regarded as "fresques manquées". Albert Aurier, the very first critic who attempted to introduce Gauguin's work to the French public wrote "You have among you a decorator of genius. Walls! Walls! Give him walls!". We can only judge Mucha's murals for Count Khuen from dim black and white photographs as the originals were destroyed in the final days of the Second World War but they were no doubt fairly conventional and academic as all his work would be for the next few years.

When the first set of murals were finished at Emmahof, Count Khuen passed on Mucha to his brother Count Egon, who lived in the ancestral castle of Gandegg in the Tyrol, who in turn sent Mucha off for a period of study in Munich. After Bavaria was raised to the dignity of a kingdom early in the nineteenth century, King Ludwig determined that his capital should become the cultural capital of central and German-speaking Europe. The public buildings he commissioned in Neo-Classical and Neo-Renaissance style made plain his desire that Munich be seen as the Athens or the Florence of the North.

8. *Autumn* (from the *Seasons* series), 1896. Coloured Lithograph, 14.5 x 28 cm. Mucha Museum, Prague.

9. *Winter* (from the *Seasons* series), 1896. Coloured Lithograph, 14.5 x 28 cm. Mucha Museum, Prague.

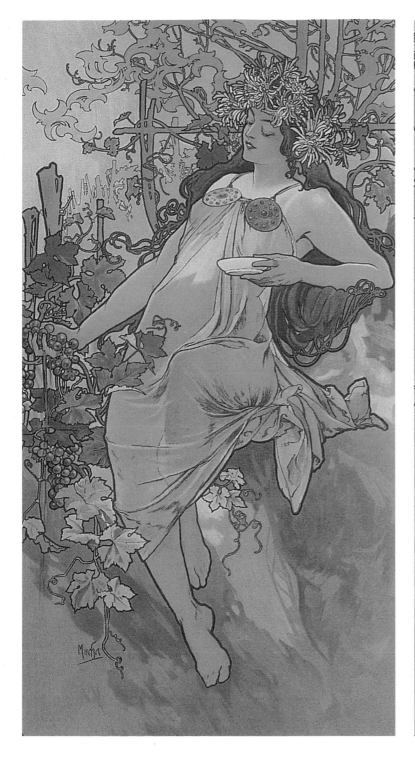
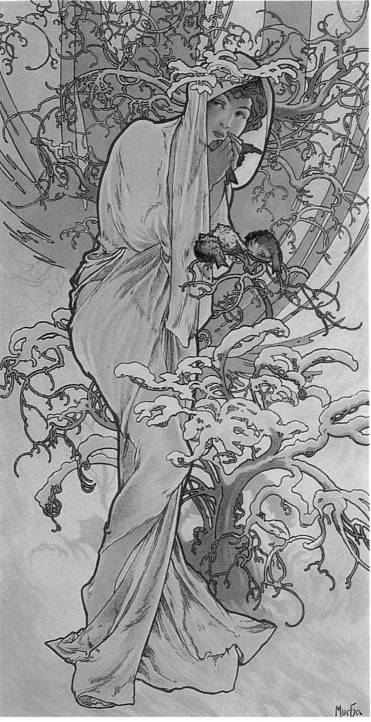

10. *Salon des Cent : 20ᵉ Exposition*, 1896. Coloured Lithograph, 43 x 63 cm. Mucha Museum, Prague.

11. *Poster for "The Cigarette Paper Job"*, 1896. Coloured Lithograph, 46.4 x 66.7 cm. Mucha Museum, Prague.

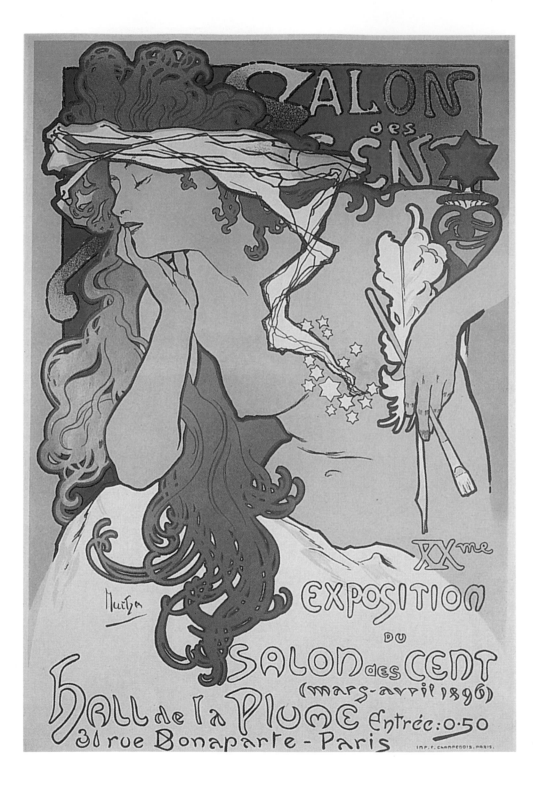

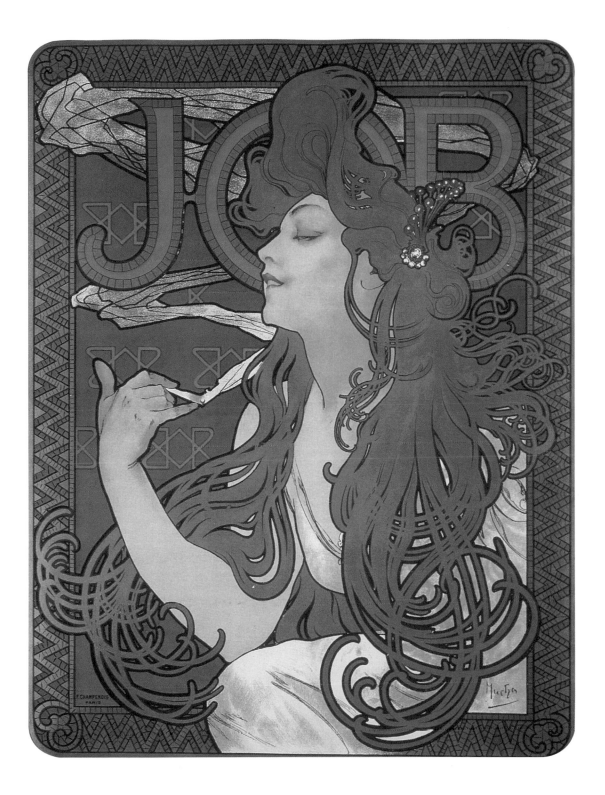

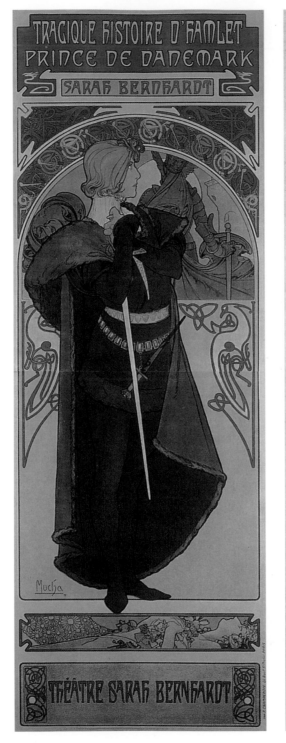

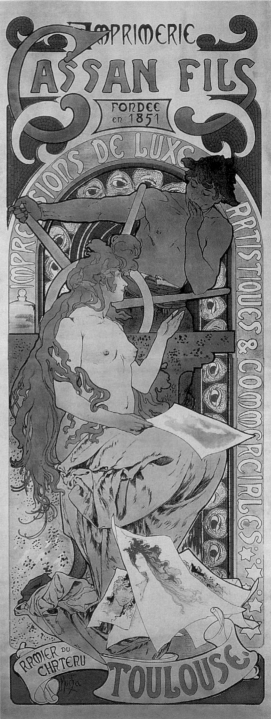

12. *Lorenzaccio,* 1896.
Coloured Lithograph,
76.5 x 203.5 cm.
Mucha Museum,
Prague.

13. *Cassan Fils*
(print shop), 1896.
Coloured Lithograph,
76 x 203.7 cm.
Mucha Museum,
Prague.

By the end of the century Munich was regarded by many as a serious alternative to Paris. Amongst the aspiring artists who were attracted to Munich were Lovis Corinth, Vassily Kandinsky, Alexei von Jawlensky, Paul Klee and Giorgio de Chirico. Even the young Picasso briefly considered going to Munich in preference to Paris. The mid 1880s was perhaps not the most propitious time to arrive. The Munich Secession which opened up a more liberal and cosmopolitan phase in the local art scene, was seven years in the future. Munich was still dominated by such dull and conservative figures as the portraitist Franz von Lenbach and the history painter Karl Theodor von Piloty, though Piloty's vast and bombastic canvas of "Thusnelda in the triumphal procession of Germanicus", which had been acquired for the Neue Pinakothek in 1874 may have encouraged Mucha's budding ambition to paint big patriotic pictures.

After the completion of a second set of murals at Emmahof, Count Khuen generously offered Mucha the choice of further study in either Rome or Paris. Wisely and fatefully his choice fell upon Paris. The timing could hardly have been better. 1888 was a momentous year in the early history of modern art. Fully recovered from the traumas of the Franco-Prussian War and the bloody massacres of the Commune, Paris was in full glory and the undisputed culture and pleasure capital of the Western World. Preparations were in hand for the forthcoming universal exhibition of 1889 and Eiffel's tower was rising on the city horizon. Gauguin in Britanny and Van Gogh in Arles were each on the brink of significant breakthroughs in their art. Together with their fellow Post-Impressionists they were laying the foundations for much of what would happen in Western art over the following half century. Mucha entered the Académie Julian where he met Serusier, Vuillard, Bonnard, Denis and other future members of the Nabis group. At the end of the summer, Serusier returned in triumphs with the "Talisman", a tiny painting on a cigar box lid that he had made in Britanny under Gauguin's tuition. Ostensibly a landscape, it was perhaps the most radically abstracted painting of the nineteenth century. Though Mucha was later on friendly terms with Gauguin and even shared his studio with him for a while in 1893 (when he took a hilarious photograph of the trouser-less Gauguin playing his harmonium) there is no indication that he was ever very interested in the more radical innovations of the Post-Impressionists or even of the older Impressionists. In this he was perhaps fairly typical of the multitude of students who had flocked to Paris and in particular to the Académie Julian from all over the world. His fellow student Maurice Denis wrote "Even the boldest students knew next to nothing about Impressionism. They admired Bastien-Lepage, spoke with respect of Puvis de Chavannes (although secretly doubting whether he could draw), discussed Peladan and Wagner, read superficial decadent literature and got excited about mysticism, the Cabala and the Chaldean calendar."

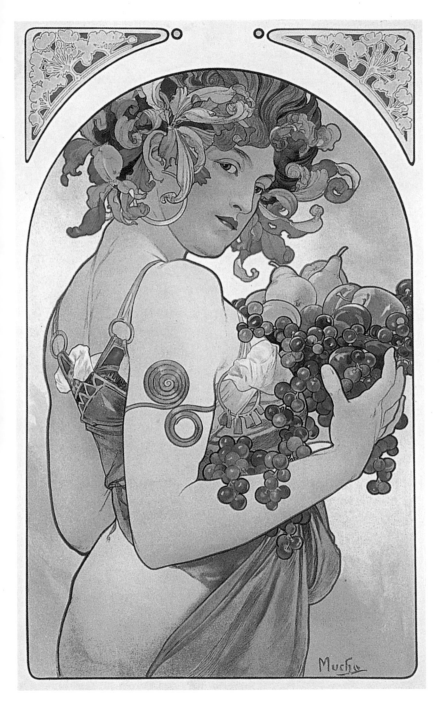
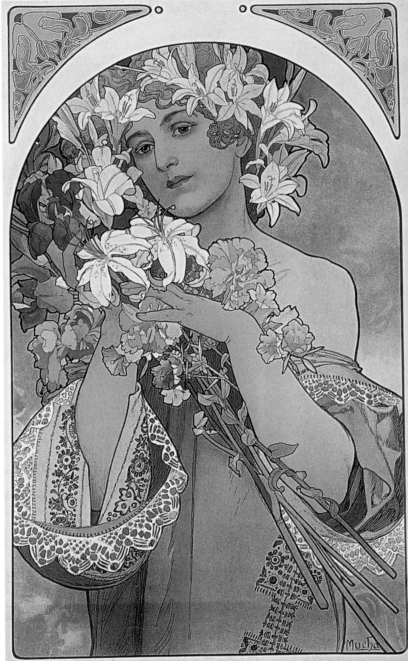

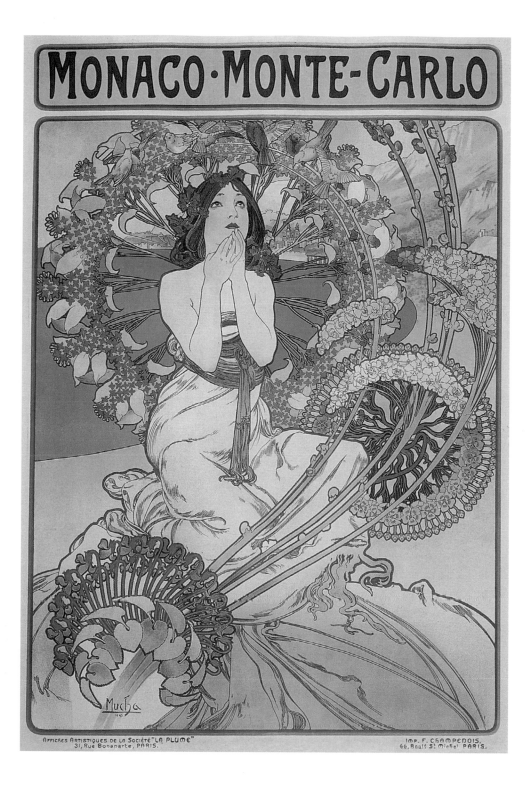

14. *Fruit,* 1897.
 Coloured Lithograph,
 44.4 x 66.2 cm.
 Mucha Museum,
 Prague.

15. *Flower,* 1897.
 Coloured Lithograph,
 44.4 x 66.2 cm.
 Mucha Museum,
 Prague.

16. *Monaco. Monte-Carlo,*
 1897.
 Coloured Lithograph,
 74.5 x 108 cm.
 Mucha Museum,
 Prague.

Though Mucha's technique and style remained essentially academic well into the 1890s, he was profoundly influenced by the Symbolist movement and the kind of mysticism that held sway in literary and artistic circles in Paris in the second half of the 1880s. The Symbolists were in reaction against the materialist and positivist philosophies that had dominated the mid-nineteenth century and that had found expression in the Realist movement and in Impressionism with its devotion to the objective recording of sensory perception. The year 1884 had brought a sea change in the cultural atmosphere of Paris and the belated recognition of the three older French Symbolist painters, Pierre Puvis de Chavannes, Gustave Moreau and Odilon Redon. After years of being dismissed as clumsy and anachronistic, Puvis triumphed at the Salon with his mysterious and hieratic "Bois Sacré", a painting that spawned a thousand imitations. Gustave Moreau and Odilon Redon were introduced to a wider public through the somewhat sensational and lurid descriptions of their works in Joris-Karl Huysmans' novel "Against Nature". This scandalous novel became a cult book and was regarded as a manifesto of decadent fin-de-siècle taste.

The Swedish playwright August Strindberg noted the abruptness of the change. On a visit to Paris in 1883 he noted that Bastien-Lepage and Manet were the artists most admired in advanced circles, but two years later "in the midst of the last spasms of naturalism, one name was pronounced by all with admiration, that of Puvis de Chavannes." The stylised flatness of Puvis' murals with their heavily contoured forms and the precious decorative quality of Moreau's paintings (what Moreau called "la richesse nécessaire") were important components of Mucha's mature style and he undoubtedly absorbed many of the attitudes and ideas of the Symbolist movement. As his son Jiři put it, "I could see in my father to what extent this mixture of theosophy, occultism and mysticism captivated its adherents, and yet Father never declared himself to be a Symbolist and would probably have been very surprised by such a classification."

At the end of 1889, Count Khuen, suddenly and without warning terminated his financial support of Mucha. Mucha had to abandon his studies at the Academie Colarossi (to which he had transferred in 1889) and endured a period of penury before he began to earn a modest living as an illustrator in the early 1890s.

What finally liberated Mucha from the strait-jacket of his academic style and unleashed his native talent and inventiveness was the arrival of the Art Nouveau style in the mid-1890s. After germinating for a decade or more in Britain, Art Nouveau finally appeared in its fully developed from in Brussels in 1892 in the designs of Victor Horta for the Maison Tassel. Here we see the exuberant whiplash line and the bold use of metal and glass in organically unified designs inspired by natural forms.

17. *Dance*, 1898.
 Coloured Lithograph,
 38 x 60 cm.
 Mucha Museum,
 Prague.

18. *Painting*, 1898.
 Coloured Lithograph,
 38 x 60 cm.
 Mucha Museum,
 Prague.

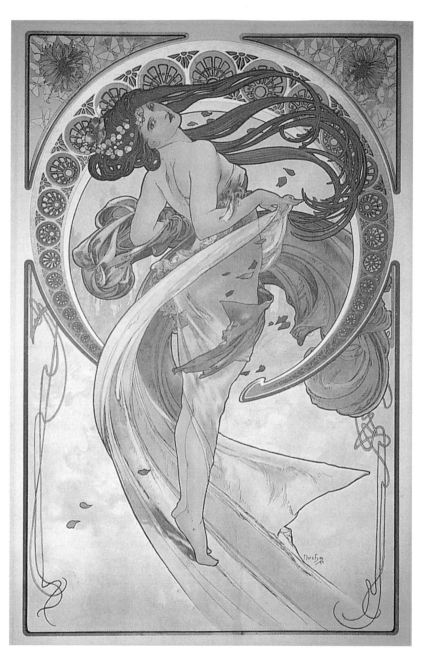
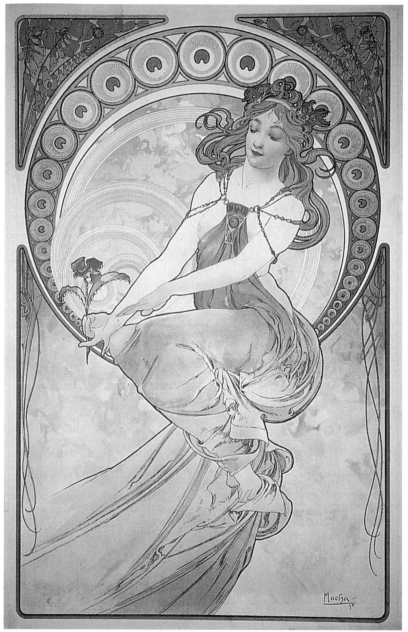

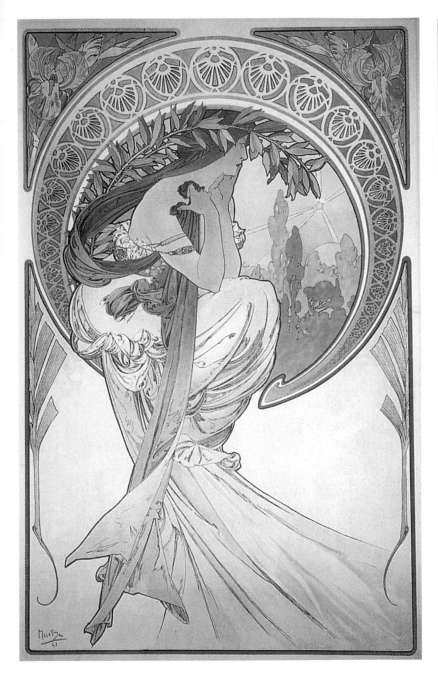

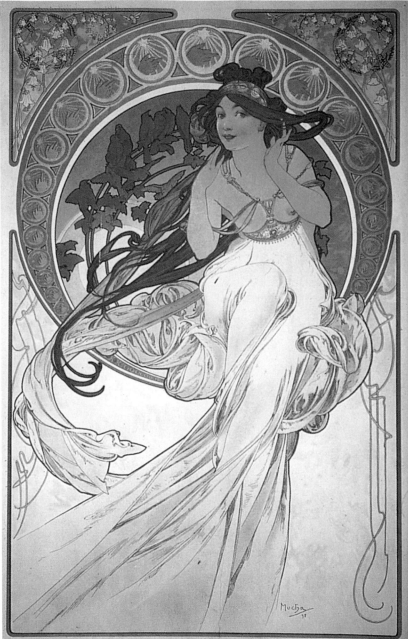

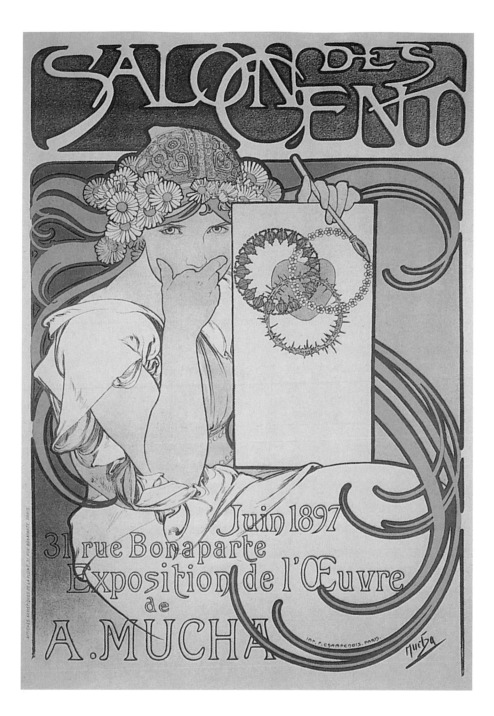

19. *Poetry,* 1898.
 Coloured Lithograph,
 38 x 60 cm.
 Mucha Museum,
 Prague.

20. *Music,* 1898.
 Coloured Lithograph,
 38 x 60 cm.
 Mucha Museum,
 Prague.

21. *Salon des Cent :
 Exposition de l'Œuvre
 de Mucha*, 1897.
 Coloured Lithograph,
 46 x 66 cm.
 Mucha Museum,
 Prague.

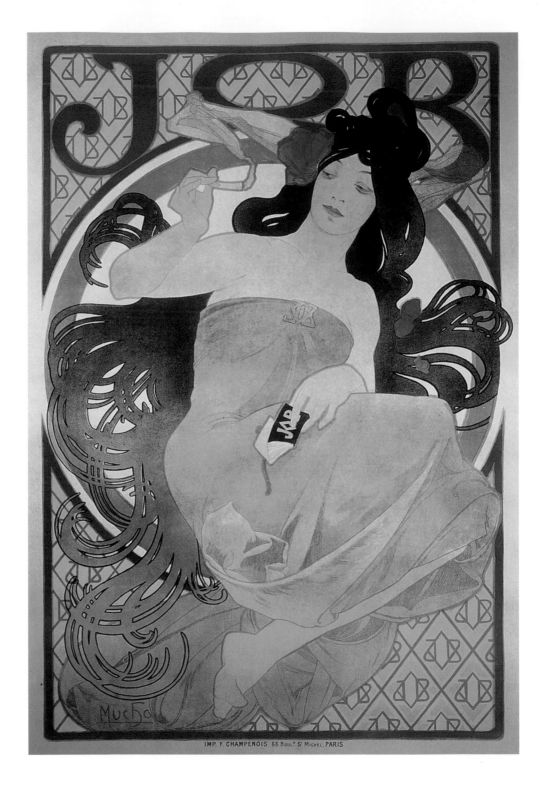

22. *JOB*, 1898.
Coloured Lithograph,
101 x 149.2 cm.
Mucha Museum,
Prague.

Like some kind of bacillus, Art Nouveau spread from place to place, often through the pages of art magazines, newly enriched with photographic illustrations and colour lithography. It mutated as it went, taking on local colour and transforming itself into something almost totally different by the time it reached such far-flung places as Glasgow, Barcelona and Vienna and eventually making appearances in such exotic and unlikely places as Moscow, Tunis and Chicago. The various names coined for the style as it made its triumphal progress, Art Nouveau, Liberty Style, Jugendstil, Secession Style, Arte Joven etc, all seem to emphasise its newness and its break with the past – most specifically with the musty historicism of the mid-nineteenth century. In fact Art Nouveau itself drew upon a myriad of earlier and exotic styles – Japanese, Celtic, Islamic, Gothic, Baroque and Rococo amongst many others. As a decorative style it was greeted with unprecedented enthusiasm but also a fair amount of scepticism and hostility.

It was frequently seen as something alien, imported from elsewhere. In Germany it was denounced as the "Belgian tape-worm style". The traditional enemies, France and Britain, tended to blame each other, with the British taking up the French term "Art Nouveau" and the French often using the "franglais" of "le Modern Style". In Paris it was noted that the two most important promoters of the style in the city, Siegfried Bing at the shop "L'Art Nouveau" and Julius Meier-Graefe at "La Maison Moderne" were both German Jews. The critic Arsène Alexandre commented sourly, "All this reaks of the depraved Englishman, the drug-addicted Jewess or the cunning Belgian or a charming mixture of these three poisons." ("Tout cela sent l'Anglais vicieux, la Juive morphinomane ou le Belge roublard, ou une agréable salade de ces trois poisons.")

It is unlikely to have passed Alexandre by that the two most characteristic Parisian examples of the style were the metro entrances of the Jewish Hector Guimard and the posters of the Czech Mucha. The style burst upon Paris in 1895 with Guimard's design for the apartment block known as the Castel Beranger, the opening of Siegfried Bing's emporium and in the very first days of the year with the appearance on the streets of Paris of Mucha's poster for Sarah Bernhardt in the role of Gismonda. The huge success of this poster turned Mucha overnight into one of the stars of the Parisian artistic firmament. Mucha was already thirty-four years old with a considerable body of work behind him and the suddenness and completeness of his transformation seem remarkable. According to Jiři Mucha, "From his first day in Paris until Christmas 1894, there is no change in his work other than a growing skill and an increased tendency towards Symbolism. His style was born suddenly, overnight, ready-made without any previous development." A similarly sudden and complete transformation can be seen in the work of the artist Gustav Klimt who three years later and at the age of thirty-five, responded to the arrival of Art Nouveau in Vienna.

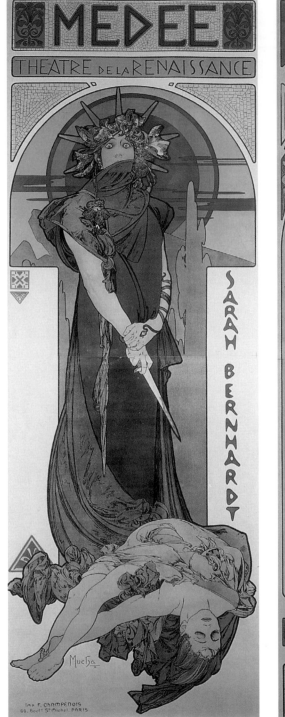

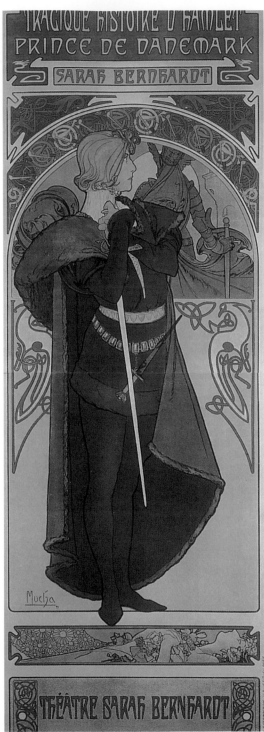

23. *Médée,* 1898.
 Coloured Lithograph,
 76 x 206 cm.
 Mucha Museum,
 Prague.

24. *Hamlet,* 1899.
 Coloured Lithograph,
 76.5 x 207.5 cm.
 Mucha Museum,
 Prague.

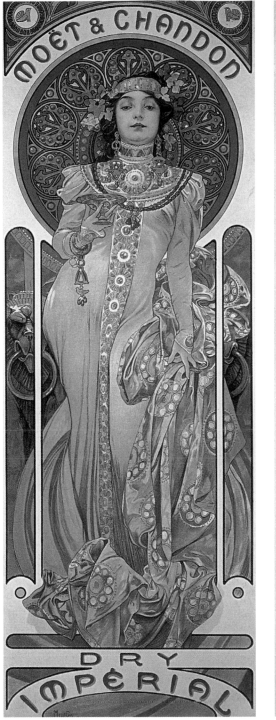

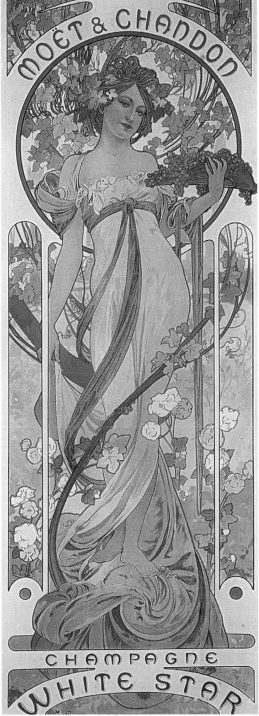

25. *Moët & Chandon –*
Dry Impérial, 1899.
Coloured Lithograph,
20 x 60 cm.
Mucha Museum,
Prague.

26. *Moët & Chandon –*
Champagne White
Star, 1899.
Coloured Lithograph,
20 x 60 cm.
Mucha Museum,
Prague.

In Mucha's case though the stylistic change was the result not only of his discovery of Art Nouveau but also of his response to the very special demands of the relatively new art form of the poster. It was the discovery of the printing technique of Lithography in 1798 by the Bavarian Alois Senefelder that enabled the nineteenth century development of the poster as an art form. Senefelder claimed that this momentous discovery was made by accident when he used a greasy pencil to jot down a laundry list for his mother on a slab of stone. He realised that when greasy ink was washed across the stone, it would stick to the crayon marks and not to the rest of the stone. It was a technique with infinite possibilities, for reproducing the effects of drawing or even painting and had the great advantage that virtually limitless numbers of copies could be produced extremely cheaply.

The development of the poster went hand in hand in the last decades of the nineteenth century with the increasingly sophisticated use of colour techniques and the influence of Japanese woodblock prints. These prints flooded the West in ever increasing quantities from 1853 when the United States navy forced Japan to open up to international trade.

Though the technique of woodblock printing is quite different in principle from lithography, it is similar in that a separate block or plate is needed for each colour. The ingenuity of the Japanese artists in using a limited number of colours to create rich and varied effects demonstrated to Western artists how the limitations of colour lithography could be turned to advantage. The Japanese also showed how text and image could be integrated into a satisfyingly unified whole.

The first great master of the Parisian poster was Jules Cheret. Dubbed the "Watteau of the streets", he developed a highly distinctive style that looked back to eighteenth century painters such as Watteau, Tiepolo and Fragonard. At the same time, his use of flat abstracted forms and bright colours and his depiction of pleasure-loving Belle Epoque Parisiennes seemed thoroughly modern. An important milestone in the history of the poster was the appearance of Henri de Toulouse-Lautrec's startling poster for the cabaret singer Aristide Bruant in 1892. With its large areas of bright, unmodulated colour, the Bruant poster caught every eye from across the widest squares and boulevards and became the talk of Paris. The periodical "La Vie Parisienne" demanded rhetorically "Who will rid us of this picture of Aristide Bruant? You cannot move a step without being confronted with it. Bruant is supposed to be an artist; why, then, does he put himself up on the walls besides the gas lamps and other advertisements? Doesn't he object to neighbours like these?" If Lautrec's bold poster of Bruant outraged as many as it delighted, Mucha's exquisitely refined and fin-de-siècle poster of Sarah Bernhardt as Gismonda finally convinced the Parisian public that posters could be great art.

27. *Iris* (from *The Four Flowers* series), 1898. Coloured Lithograph, 43.3 x 103.5 cm. Mucha Museum, Prague.

28. *Lily* (from *The Four Flowers* series), 1898. Coloured Lithograph, 43.3 x 103.5 cm. Mucha Museum, Prague.

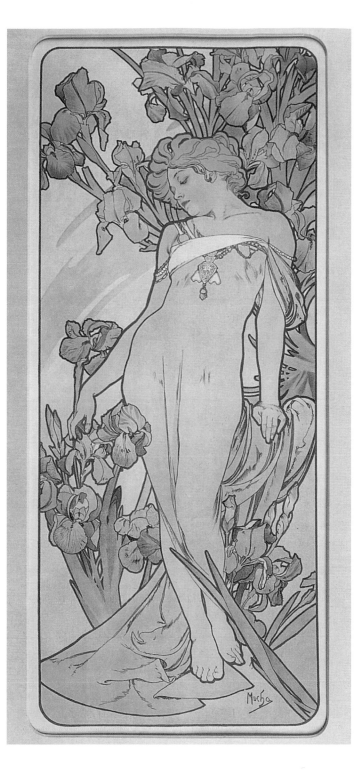 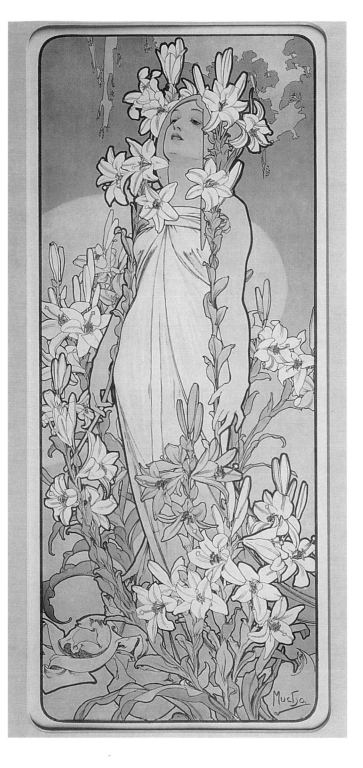

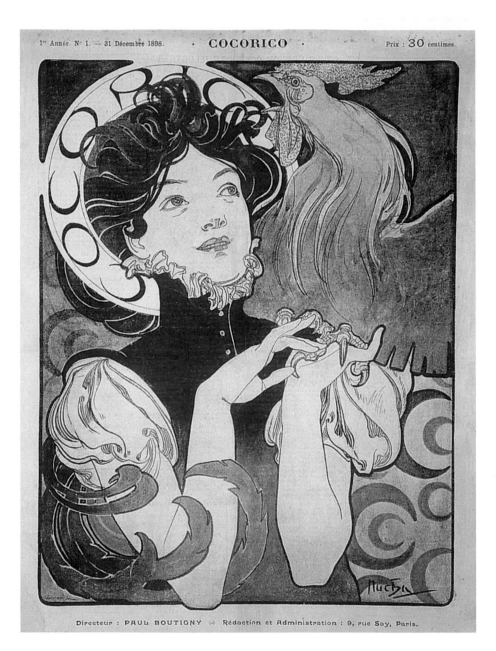

29. *Cocorico,* magazine
 cover, n°. 1, December
 1898. Lithograph,
 24 x 31 cm.
 Mucha Museum,
 Prague.

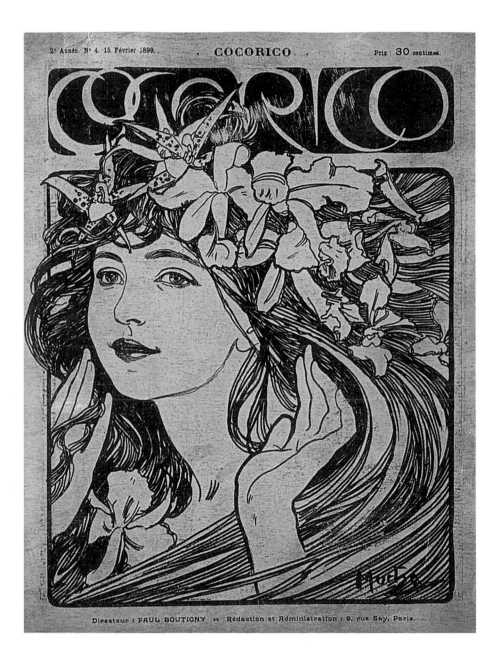

30. *Cocorico,* magazine
 cover, n°. 4, February
 1899. Lithograph,
 24 x 31 cm.
 Mucha Museum,
 Prague.

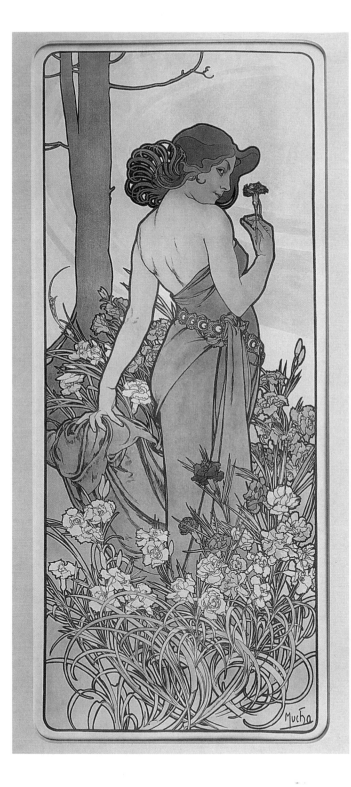
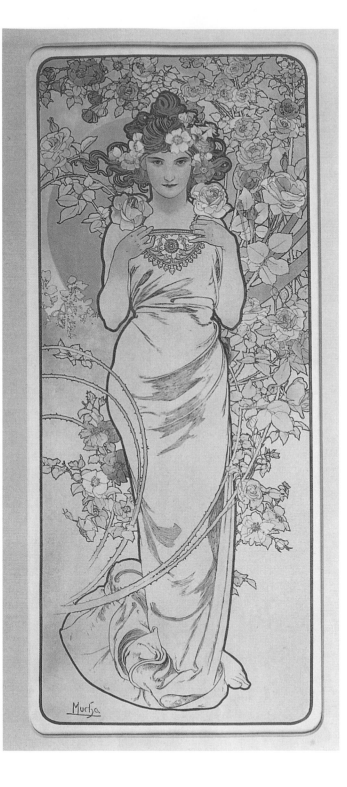

Mucha's encounter with the great actress Sarah Bernhardt was another happy co-incidence that was to transform his life and his career. In the mid 1890s, Bernhardt was at the very pinnacle of a glorious career that dated back to the 1860s. Thanks to railways, steamships, mass circulation newspapers and later to moving film and gramophone records and above all to her skilful manipulation of these new possibilities, Bernhardt enjoyed a world fame beyond that of any earlier performing artist. Like the singer Madonna in our own day she was intensely aware of the importance of her image and of the need to keep it fresh and changing. Her relationship with Mucha in the 1890s was a symbiotic one of enormous benefit to both.

Countless portraits of Sarah Bernhardt were made over her long career, beginning with the touching series of daguerreotypes of the youthful Sarah, made by the famous photographer Nadar in the 1860s. Bernhardt's friend and admirer William Graham Robertson was convinced that no portrait could capture her. "This strange dream-beauty was impossible to transfer to canvas; no portrait of her holds even the shadow of it." He dismisses Bastien-Lepage's portrait as "little more than a caricature" and goes on to damn most of the others. "Georges Clairin's immense canvas, full of frills, flounces, fringes, dogs and cushions, like an odd lot at a jumble sale, is of no value as a likeness; Gandara's portrait is a clever study of a pink dress, but Sarah is not inside it. She looked so paintable, yet no one could paint her." Oddly Robertson fails even to mention Mucha's posters. They were not accurate likenesses and were not intended as such (Bernhardt was, after all fifty years old when the first of them was made). Nevertheless they have done more to preserve the poetry and beauty of her aura for posterity than any other images.

Bernhardt took an intense interest in art. She herself was a gifted amateur sculptress described by George Bernard Shaw as "very clever with her fingers". Though she was uninterested in the more advanced tendencies in the French art of her time, she greatly admired the English Pre-Raphaelite painter Edward Burne-Jones and went to visit him in his studio when she was in London. Unfortunately her desire to have him make her portrait came to nothing. Burne-Jones' delightfully expressed mock terror of meeting the Divine Sarah in letters to William Graham Robertson conveys something of the awed admiration with which she was regarded.

"Will you give the enclosed to the Supreme and Infinitely Glorious One, kneeling as you give it. She is not to dream of troubling to answer. Who am I, great powers, that she should take a moment's trouble!"

"Yes, Wednesday will do lovely and I'll be with you at 7, and She has but to fix her own time about Briar Rose and it shall be my time and everybody else's time."

31. *Carnation* (from *The Four Flowers* series), 1898. Coloured Lithograph, 43.3 x 103.5 cm. Mucha Museum, Prague.

32. *Rose* (from *The Four Flowers* series), 1898. Coloured Lithograph, 43.3 x 103.5 cm. Mucha Museum, Prague.

33. *Awake in the Morning*
 (from the *Time of Day*
 series), 1899.
 Coloured Lithograph,
 39 x 107.7 cm.
 Mucha Museum,
 Prague.

34. *Daytime Dash*
 (from the *Time of Day*
 series), 1899.
 Coloured Lithograph,
 39 x 107.7 cm.
 Mucha Museum,
 Prague.

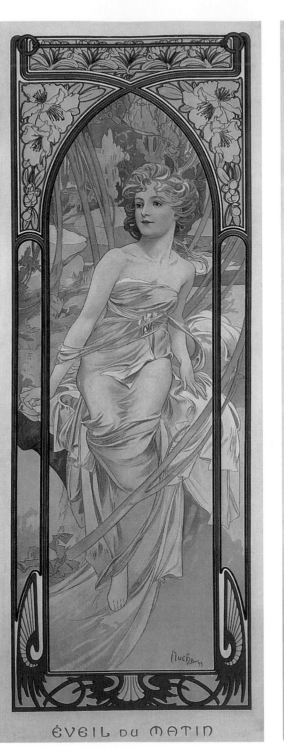

ÉVEIL DU MATIN

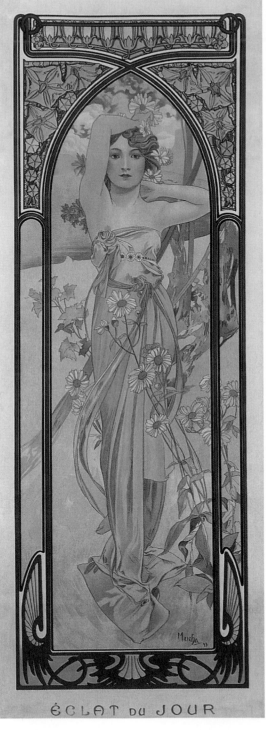

ÉCLAT DU JOUR

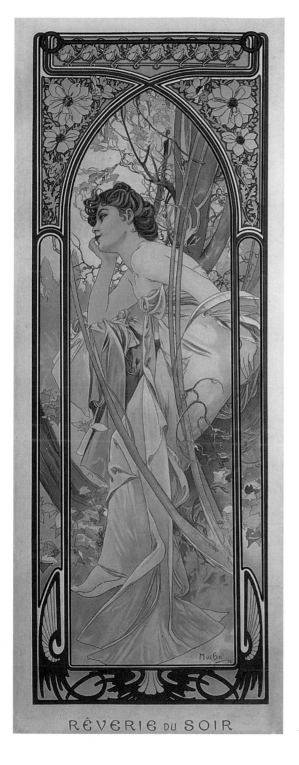

RÊVERIE DU SOIR

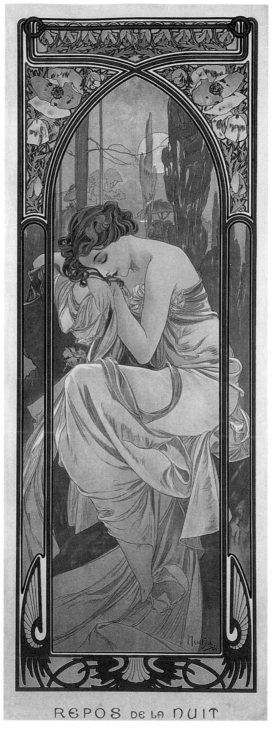

REPOS DE LA NUIT

35. *Evening Reverie*
(from *the Time of Day*
series), 1899.
Coloured Lithograph,
39 x 107.7 cm.
Mucha Museum,
Prague.

36. *Nightly Rest*
(from *the Time of Day*
series), 1899.
Coloured Lithograph,
39 x 107.7 cm.
Mucha Museum,
Prague.

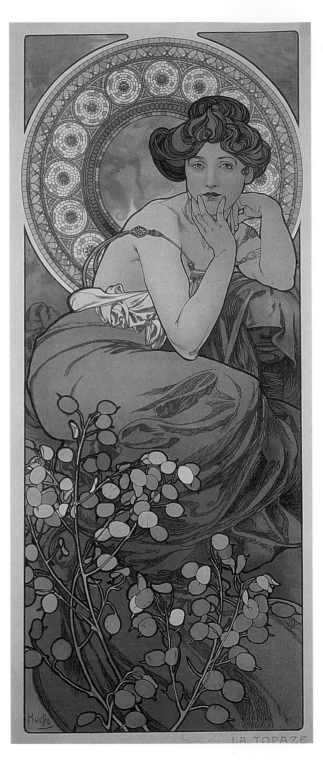

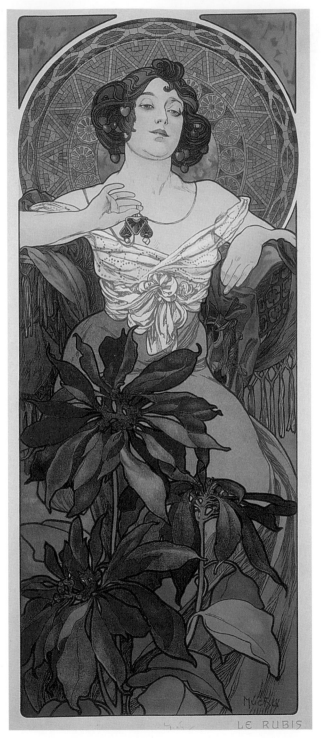

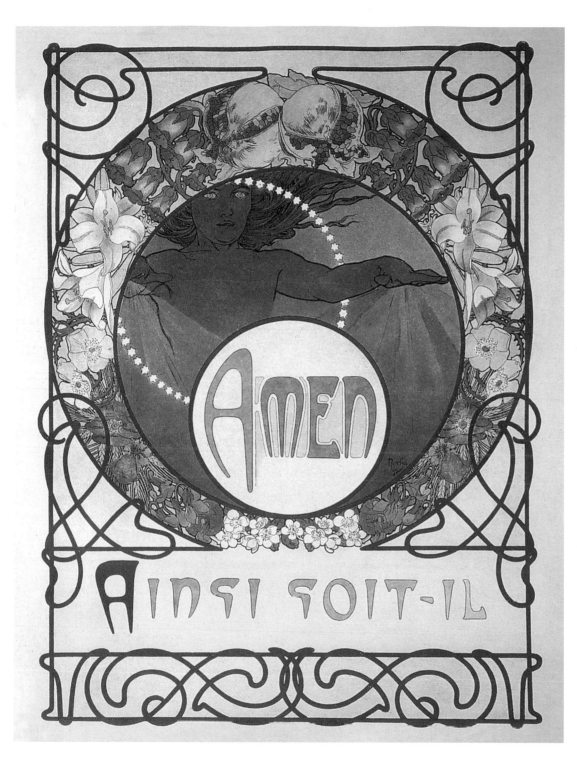

37. *Topaz*
(from the *Precious Stones* series), 1900.
Coloured Lithograph,
30 x 67.2 cm.
Mucha Museum,
Prague.

38. *Ruby*
(from the *Precious Stones* series), 1900.
Coloured Lithograph,
30 x 67.2 cm.
Mucha Museum,
Prague.

39. *Amen* (extract from *Le Pater*), 1899.
Coloured Lithograph,
25 x 33 cm.
Mucha Museum,
Prague.

"Tell me how long She stays and how long is to be seen and worshipped in this new play – for go I must though I shall be ill for a week after it."

"Even if I were free tomorrow I don't think I could meet Her at lunch. – I cannot speak French even to a waiter and what could I say to her?"

"No, come with Her and gently interpret what She says to me – and I will gape open-mouthed and be quite happy. And at the last moment let Her change Her mind and alter the day or hour. On no account is She to be bored or tired but to have everything Her own lovely way and at a minute's notice."

 The story of how Mucha came to make his great breakthrough with his poster of Gismonda as related by the artist himself, has the flavour of an old-fashioned Hollywood biopic. On the morning of Christmas Day 1894 Mucha turned up at Lemercier's printing shop in the Rue de Seine on an errand to help an artist friend who had gone away over the holiday period. While he was there Sarah Bernhardt phoned to say that she needed a poster for her new play Gismonda, one of a series written to showcase her histrionic talents by the popular playwright Victorien Sardou (two of which, "Tosca" and "Fedora", have survived in operatic settings by Puccini and Giordano.) The poster was needed by New Year's Eve. With little hope of finding another artist at such short notice over the Christmas period, the manager, a certain M. de Brunhoff, turned in desperation to Mucha and persuaded him to attend a performance that very night. The impoverished Mucha had no suitable clothes for such a glamorous occasion. "What was I to do? I had no tails. I managed to hire a suitable tail-coat for ten francs, but as none of the trousers fitted, I decided to wear the ordinary black trousers I wore all the time. At night all cows are black, I told myself. But that was not all. I'd have to have a top hat."

He managed to borrow "a very old one that must have dated back to the forties; it was like a battleship and on the big side for me. The springs were all twisted and it wobbled when I put it on, so that I had to steady it with a finger to keep it from falling over my eyes. In this attire I turned up in the wings at the Théâtre de la Renaissance, with a sketchbook and all the pencils I needed. Sarah was sublime, especially in the bit where she goes to church on Easter Sunday to the sound of bells and gregorian chant. I sketched her dress, the golden flowers in her hair, the wide sleeves and a palm leaf in her hand. All the time the top hat kept swaying on my head and, as soon as I started drawing, it fell over my eyes. This made things very difficult because I couldn't see the paper. But I was afraid to take the hat off as it was only lent and somebody might steal it. A few steps away stood two very elegant gentlemen, highly amused at my predicament. I must have aroused their sympathy because one of them came to me and said; "Put your hat on the chair here; I'll guard it for you."

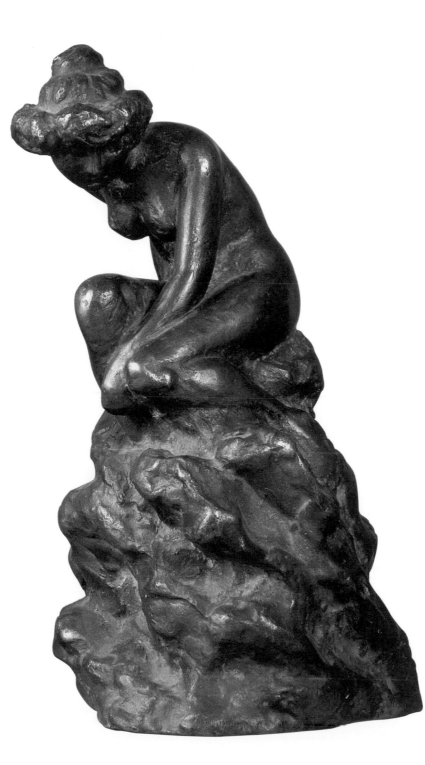

40. *Nude on a Rock*, 1899.
Bronze, height: 27 cm.
Mucha Museum,
Prague.

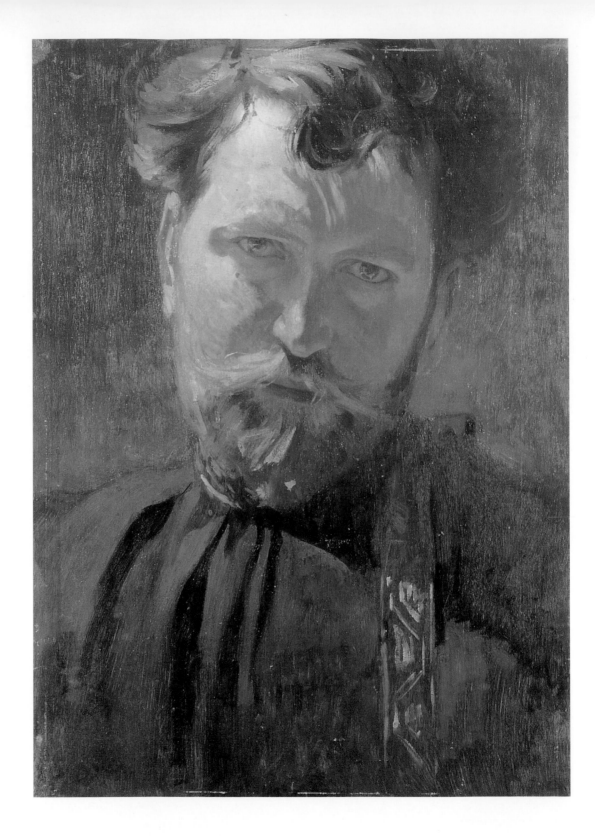

41. *Self Portrait*, 1899.
Oil on cardboard,
21 x 32 cm.
Mucha Museum,
Prague.

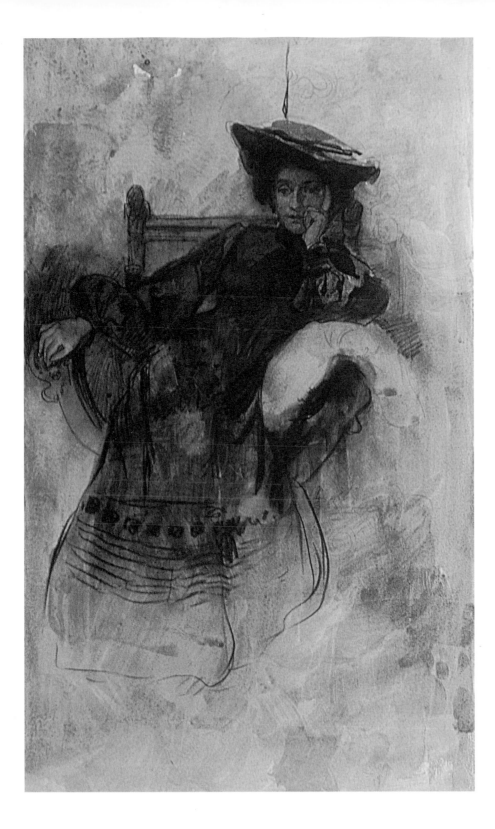

42. *Study of a Woman
Sitting in an
Armchair*, c. 1900.
Ink drawing on paper,
43.5 x 60.5 cm.
Mucha Museum,
Prague.

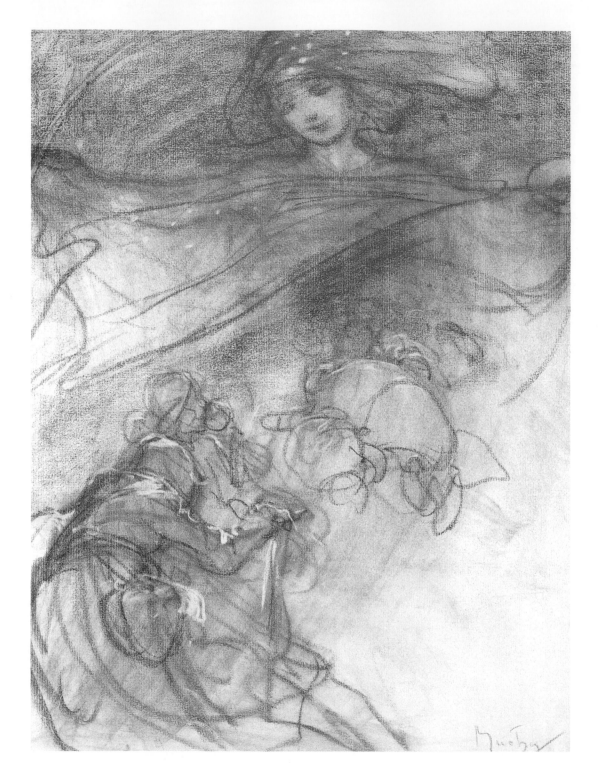

43. *Holy Night*, c. 1900.
Pastel on blue paper,
45.5 x 60 cm.
Mucha Museum,
Prague.

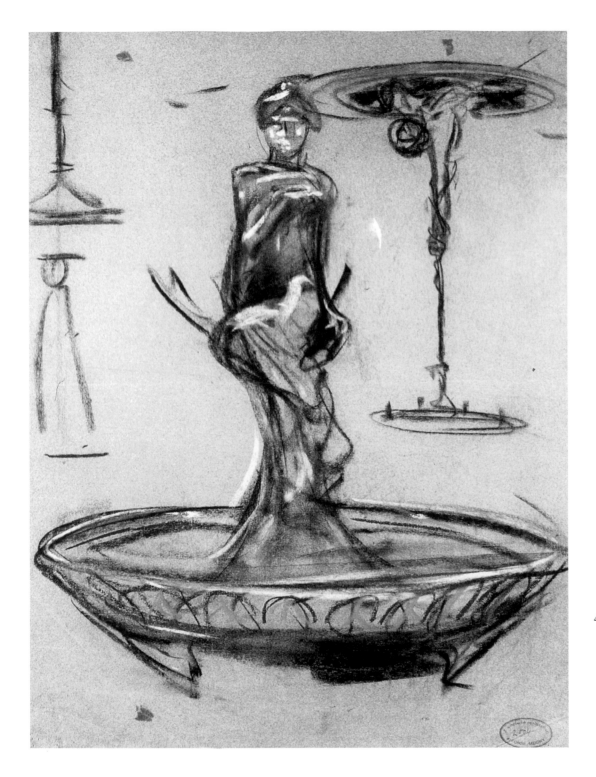

44. *Study for a Fountain and Sketches*, c. 1900. Charcoal drawing and pencil on blue paper, 47 x 61 cm. Mucha Museum, Prague.

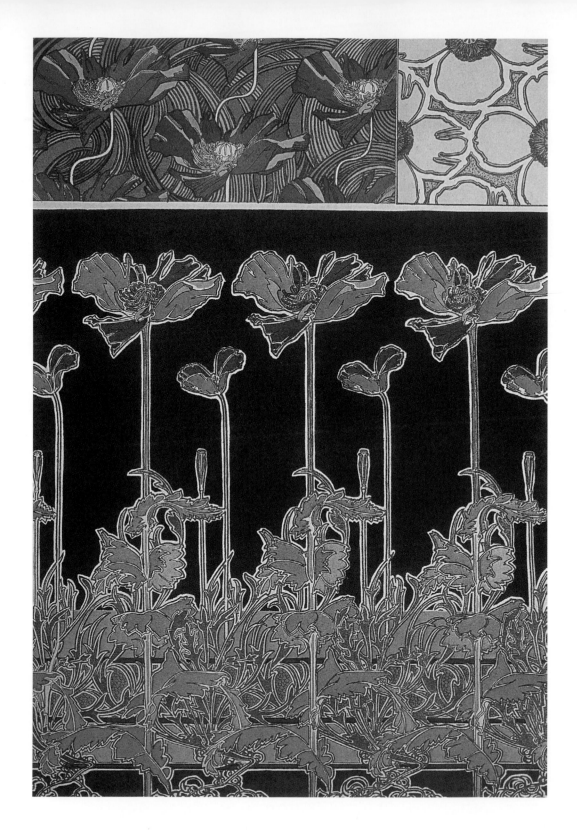

45. *Documents décoratifs*
Board 38, 1902.
Coloured Lithograph,
33 x 46 cm.
Mucha Museum,
Prague.

It was Sardou. After the theatre in a scene that seems pure Hollywood, Mucha went to a café with de Brunoff and sketched his idea for the poster on a marble table top that the café proprietor kept and later sold). The elongated format of the poster (influenced by a type of Japanese print that in turn derives from Chinese scroll painting) necessitated the use of two lithographic stones. The work was pushed through so rapidly that Mucha had no time for the finishing touches to the lower half and the two halves failed to match up perfectly. The end result was utterly different from the brasher posters produced by Cheret and Lautrec. So bizarre did it seem with its unusual format, hieratic composition, stylised detail and its delicate and muted colours that the printer and the manager were disconcerted and fully expected a disaster. Luckily there was no time to commission another poster and above all the great Sarah herself was enchanted. When Mucha went to see her in her dressing room, he reported "My poster was up on the wall, Sarah was standing in front of it, unable to tear her eyes away. When she saw me, she came and embraced me. In short, no disgrace, but success, great success."

Bernhardt's judgement was vindicated. When the poster appeared on the walls of Paris in January 1895 it created a sensation. As Jerome Doucet wrote in the *Revue Illustrée*, "This poster made all Paris familiar with Mucha's name from one day to the next... This poster, this white window, this mosaic on the wall, is a creation of the first order, which has well deserved its triumph." The poster was used in London as well and clearly made a profound impression on the sculptor Alfred Gilbert, then at work on his grandiose and very fin-de-siècle masterpiece, the tomb of the Duke of Clarence at Windsor Castle. The exquisite polychromed bronze statuettes that adorn the tomb show more than a passing resemblance to Gismonda.

The firm of Lemercier printed 4000 copies of the poster for Sarah Bernhardt but tried to hang on to some of this number for themselves. Bernhardt was forced to take legal action to regain possession of the final 550 copies. The court records indicate that Mucha may have taken a little poetic licence in his account of the rapid creation of his first masterpiece and that the poster was probably not printed until the first days of the new year rather than on New Year's Eve as he claimed. Extraordinary though Mucha's story was, even more fantastic versions circulated of his discovery by Sarah Bernhardt. One version that must have galled this patriotic Czech, had him as a Gypsy violinist encountered by Bernhardt on a tour of Hungary.

The Gismonda poster brought Mucha not only overnight fame but also financial security in the form of a six-year contract to work for Sarah Bernhardt. A succession of striking posters for *La Dame aux Camélias, Lorenzaccio, La Samaritaine, Médée, Tosca* and *Hamlet* appeared over the next four years.

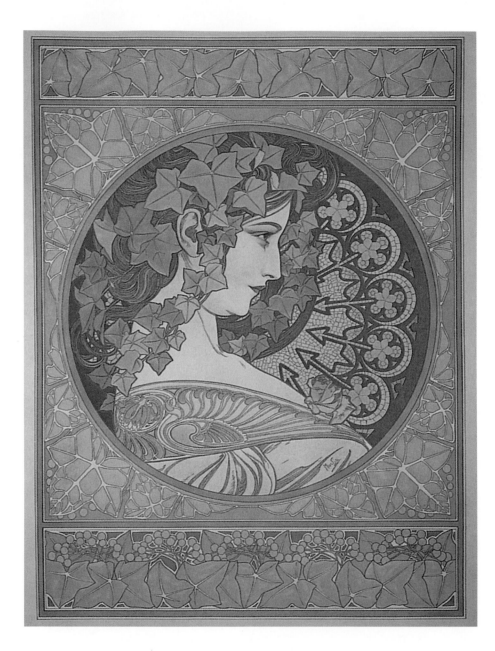

46. *Ivy*, 1901.
Coloured Lithograph,
39.5 x 53 cm.
Mucha Museum,
Prague.

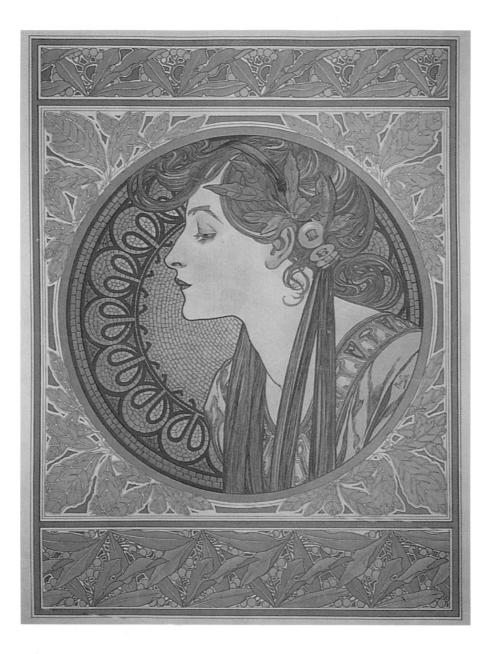

47. *Laurel*, 1901.
Coloured Lithograph,
39.5 x 53 cm.
Mucha Museum,
Prague.

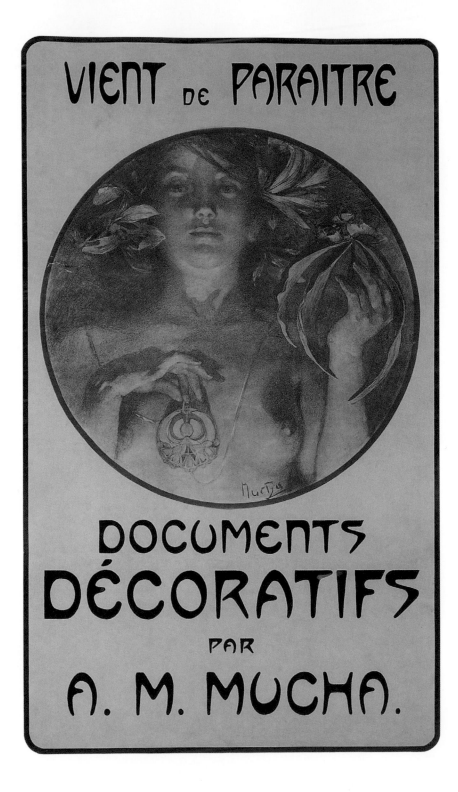

48. Poster for *Documents décoratifs*, 1902. Coloured Lithograph, 44.9 x 75.5 cm. Mucha Museum, Prague.

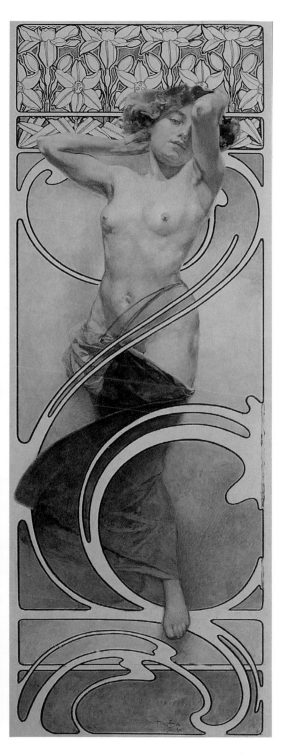

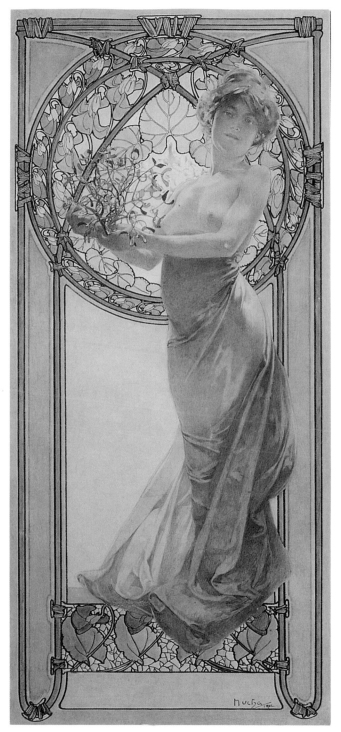

49. Nude in a decorative
 frame. Drawing for
 Documents décoratifs
 Board 10, 1902.
 Pencil, Indian ink and
 white highlights on
 paper, 23 x 61 cm.
 Mucha Museum,
 Prague.

50. Woman holding
 mistletoe. Drawing
 for *Documents
 décoratifs* Board 11,
 1902. Ink drawing
 and white highlights
 on paper, 23 x 61 cm.
 Mucha Museum,
 Prague.

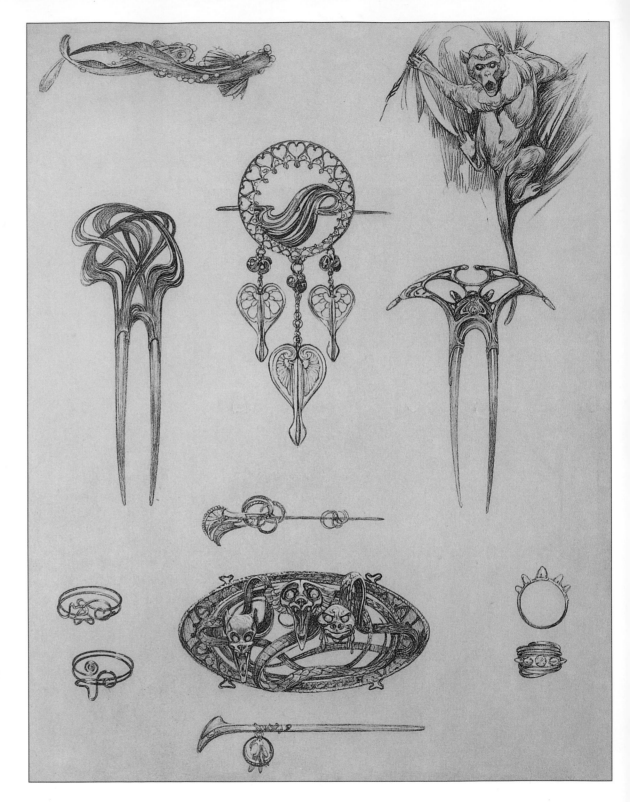

51. *Documents décoratifs*
Board 51, 1902.
Lithograph,
33 x 46 cm.
Mucha Museum,
Prague.

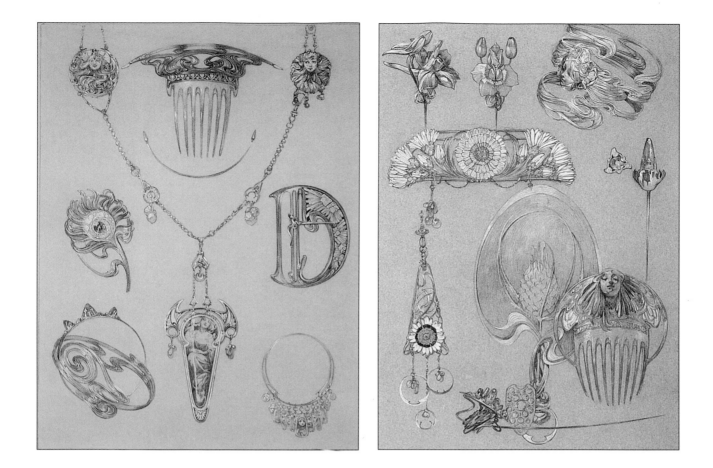

Bernhardt agreed to pay Mucha a monthly retainer of 3000 francs, plus 1,500 francs for each new poster. (Jiři Mucha reckons that Bernhardt made at least 130,000 francs profit on sales of the Gismonda poster alone.) For this money Mucha was expected to oversee every visual aspect of Bernhardt's theatre productions and to provide designs for sets, costumes and props, including, on occasion, jewellery.

Mucha's long collaboration with Bernhardt gave him plenty of opportunity to observe her closely and he left a lengthy verbal description of her that is remarkable for its detailed objectivity that tempers his very evident admiration.

"Sarah had a low forehead which she was a little ashamed of and always carefully concealed it with plenty of hair. Her main object was to emphasise her eyes which were somewhat small in relation to her cheeks and forehead. The shadow under her curls completely filled the depression round her eyes and, with a few deft touches of mascara, eyes that a moment before had been almost expressionless, acquired unexpected depth and the proper dimensions. In profile her somewhat wide nose had an exceptionally fine line: its bridge forcefully revealed her artistic independence and personality, a small bump

52. Drawing for *Documents décoratifs* Board 49, 1902. Pencil and white highlights on paper, 39 x 51 cm. Mucha Museum, Prague.

53. Drawing for *Documents décoratifs* Board 50, 1902. Pencil and white highlights on paper, 39 x 50.5 cm. Mucha Museum, Prague.

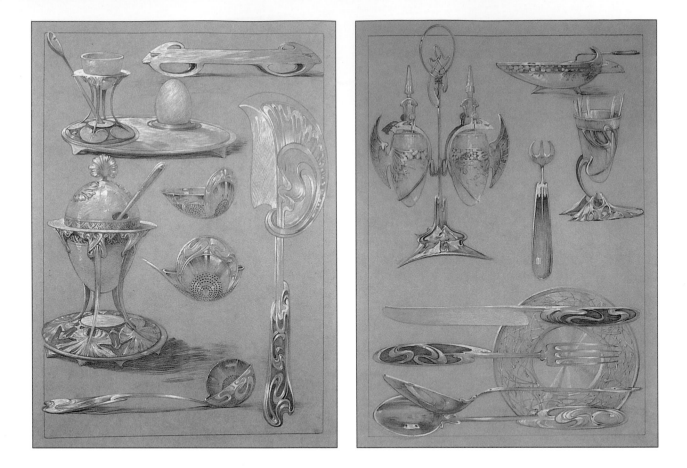

on the ridge showed her fighting qualities, while its interesting termination in a slightly turned-up tip indicated vivid imagination and volatility. Long, narrow nostrils testified to her little developed and therefore easily controlled sensuality. Her mouth was peculiarly remarkable; the lips were beautifully symmetrical with a clean groove on the upper one; when compressed, they formed an almost straight line, only slightly raised at the corners. In tragic parts she was able to keep them drooping for several hours and convey a completely altered personality. Her lower lip was thrust slightly forward and her firm chin, indicated an exceptionally resolute character. She preferred to keep her beautiful, long neck covered, right up to the ears, particularly in society, since the neck first gives away age in fine wrinkles which no cosmetics or massage can remove. But on the stage, with artificial light and good make-up – particularly later on in her fifties, when she came into her real beauty – her bare neck and shoulders were magnificent."

The success of his work for Bernhardt brought Mucha numerous other commissions for posters. Following in the footsteps of Cheret, Mucha created an instantly recognisable ideal female type that he used to advertise everything from cigarettes and soap to beer and bicycles.

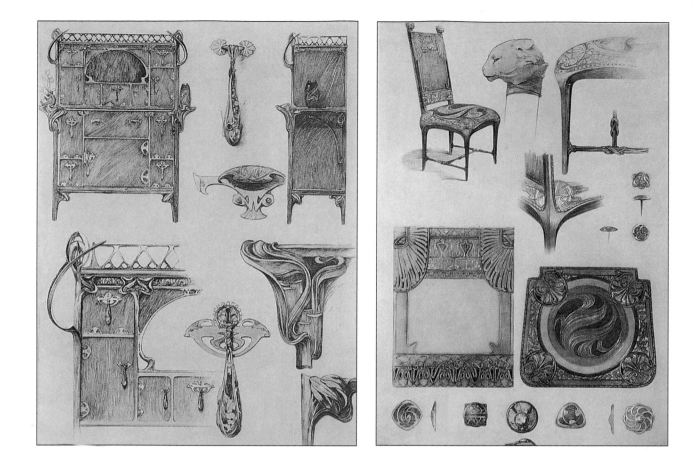

This type lies somewhere between the earthy gaiety of Cheret's blond or red-headed good-time girls with their heavily corseted, hour-glass figures, the morbid refinement and melancholy of the Pre-Raphaelite type and the sinister allures of the fin-de-siècle femme fatale, combining elements of all three.

A superb and characteristic example is the poster for Job cigarettes. An image of a young woman smoking was in itself a daring thing at a time when no respectable woman would be seen smoking in public. As late as 1909 the Italo-German composer Ermanno Wolf-Ferrari wrote the charming opera "Il Segreto di Susanna" concerning the misadventures of a young woman who attempts to hide from her new husband the guilty secret that she smokes. The physical type of the girl in the Job poster, with her strong chin and abundant hair derives from the Pre-Raphaelite type created by Dante Gabriel Rossetti.

The pose with raised head and ecstatically parted lips and half closed eyes is taken directly from Rossetti's painting "Beata Beatrix", though Mucha has attempted to disguise his theft by reversing the image.

56. *Documents décoratifs*
Board 64, 1902.
Lithograph,
33 x 46 cm.
Mucha Museum,
Prague.

57. *Documents décoratifs*
Board 71, 1902.
Lithograph,
33 x 46 cm.
Mucha Museum,
Prague.

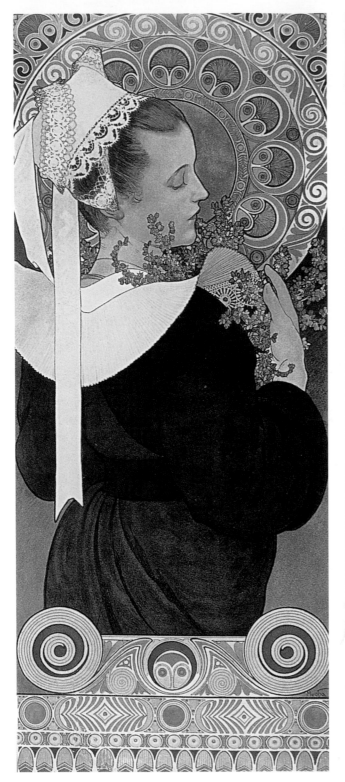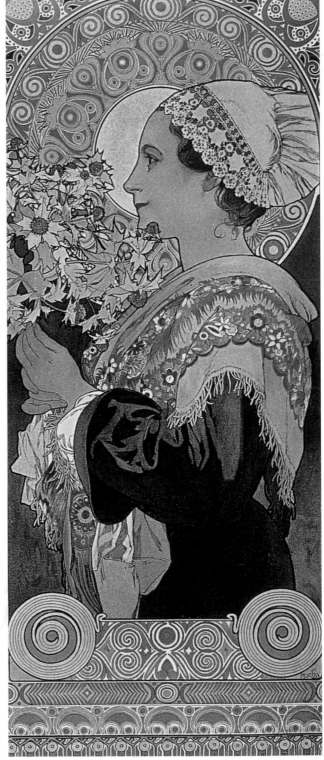

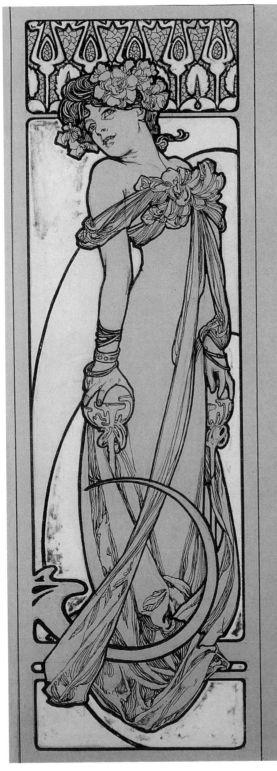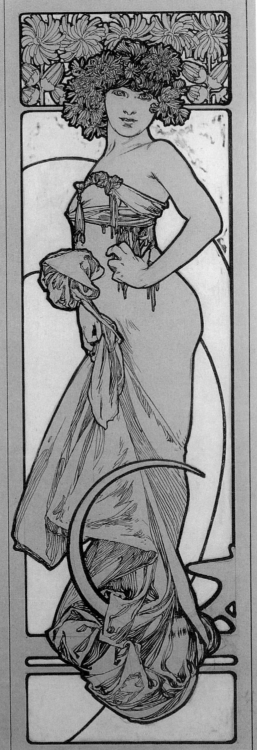

58. *Heather,* 1902.
 Coloured Lithograph,
 35 x 74 cm.
 Mucha Museum,
 Prague.

59. *Sea Holly,* 1902.
 Coloured Lithograph,
 35 x 74 cm.
 Mucha Museum,
 Prague.

60. Two Women Standing,
 Drawing for
 Documents décoratifs
 Board 45, 1902.
 Pencil, feather and
 indian ink on paper,
 47.5 x 62 cm.
 Mucha Museum,
 Prague.

Another was the pavilion of the American dancer Loie Fuller, known as the "Electric Fairy" who managed to combine electric lighting and Art Nouveau in an act in which she leapt around the stage trailing veils from poles in order to create curvilinear patterns. Soon after, fearing that electric light bulbs might loose their novelty she asked Marie Curie to make her radioactive so that she would be able to glow in the dark without the aid of wires and plugs. Loie Fuller was immortalised by the exquisite Art Nouveau lamps of Raoul Larche and by the slightly tongue-in-cheek lithographs of Toulouse-Lautrec. For the posters advertising her performances at the Folies Bergère she went to Cheret rather than to Mucha who surely would have been more suited to the task. Nevertheless Mucha had his hands more than full at around this time. The Austrian government was keen to exploit the prestige of the most famous subject of the Emperor Franz Josef, resident in Paris. Mucha was invited to select the paintings for the Austrian section of the exhibition (that would include Klimt's controversial ceiling paintings for the University of Vienna.

He was also invited to design a pavilion for the newly-annexed provinces of Bosnia-Herzegovina. In accepting this project, Mucha could have been accused of collaborating in the Habsburg oppression of a fellow Slav people, but he, himself, saw it differently. "Once again I was doing historical painting, but this time not about Germany but a brotherly Slav nation. Describing the glorious and tragic events in its history, I thought of the joys and sorrows of my own country and of all the Slavs. And so, before I had completed the south Slav murals, I had made up my mind about my future big work which was to become 'The Slav Epic' and I saw it as a great and glorious light shining into the souls of all people with its clear ideals and burning warnings."

In addition to his work for the Austrian government, Mucha provided designs for the display of the perfumer Houbigant, and his own work in several different media was represented in various sections of the exhibition. He also produced designs for a monstrous "Pavilion of Man" adorned with vast female figures that would have been more appropriately named the "Pavilion of the Mucha Woman", and which was intended to replace the Eiffel Tower as the principal monument of Paris. Even though this last project came to nothing it was the moment of Mucha's greatest triumph. Looking back on it though, he commented, "I cannot rave about these glorious days. My only memory at the mention of the World Exhibition is and will be exhaustion, utter weariness…"

After Art Nouveau reached its zenith in 1900, the vogue for it passed quickly and already by the next major international exhibition in Turin in 1902, it was apparent that a reaction had set in. Art Nouveau was a luxurious and elitist style that unlike its successor Art Deco did not lend itself well to cheap imitation and mass production. The seeds of the decline of Art Nouveau lay in the popular successes of 1900.

67. *Jaroslava and Jiři –* the Artist's Children, 1919. Oil on canvas, 82.8 x 82.8 cm. Mucha Museum, Prague.

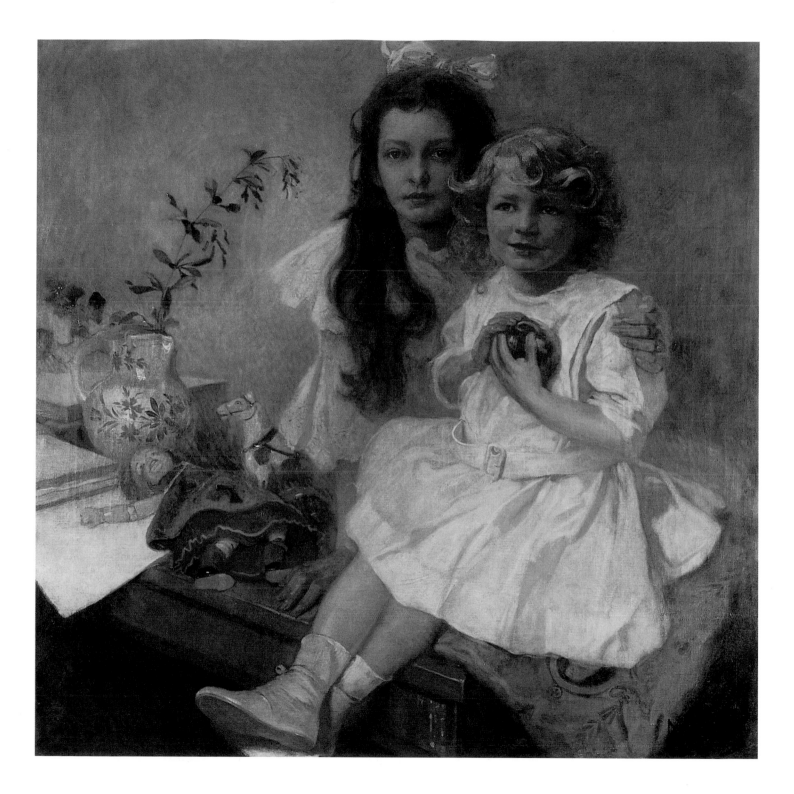

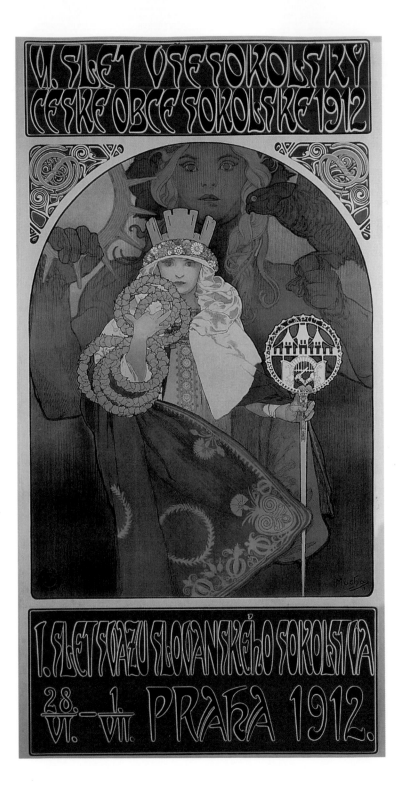

68. *6th Sokol Festival,*
 1912.
 Coloured Lithograph,
 82.3 x 168.5 cm.
 Mucha Museum,
 Prague.

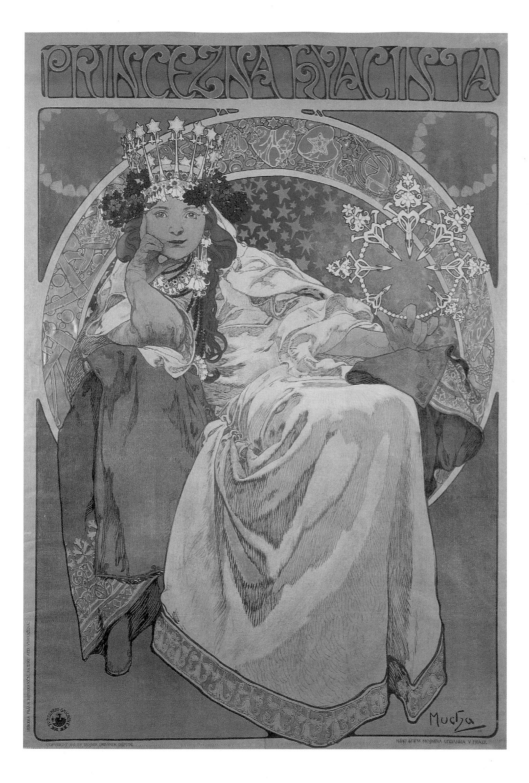

69. *Princess Hyacinthe*,
 1911.
 Coloured Lithograph,
 83.5 x 125.5 cm.
 Mucha Museum,
 Prague.

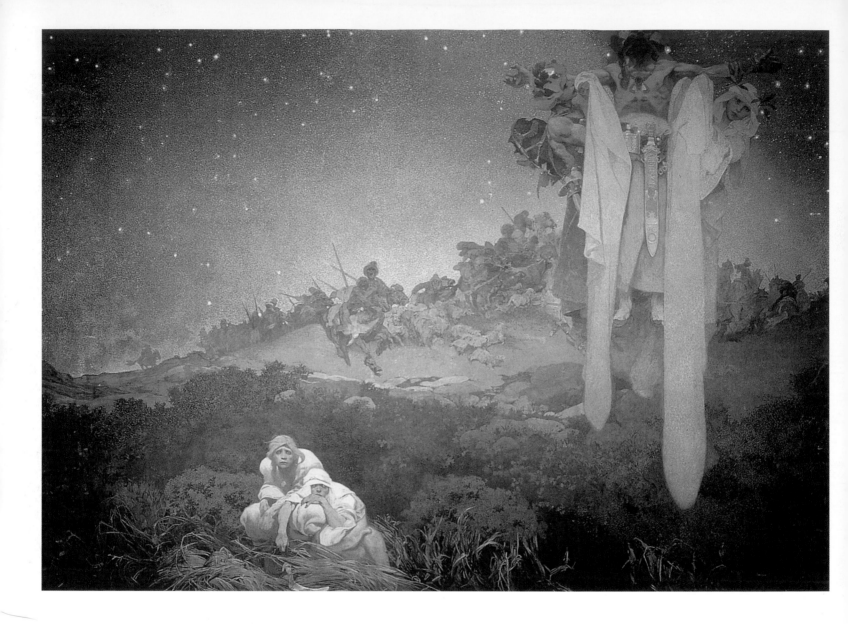

70. *The Slavs in Their
Original Homeland
"Between the Knout of the
Turcs and the Sword of the
Goths."*, 1912. Distemper
on canvas, 810 x 610 cm.
Mucha Museum, Prague.

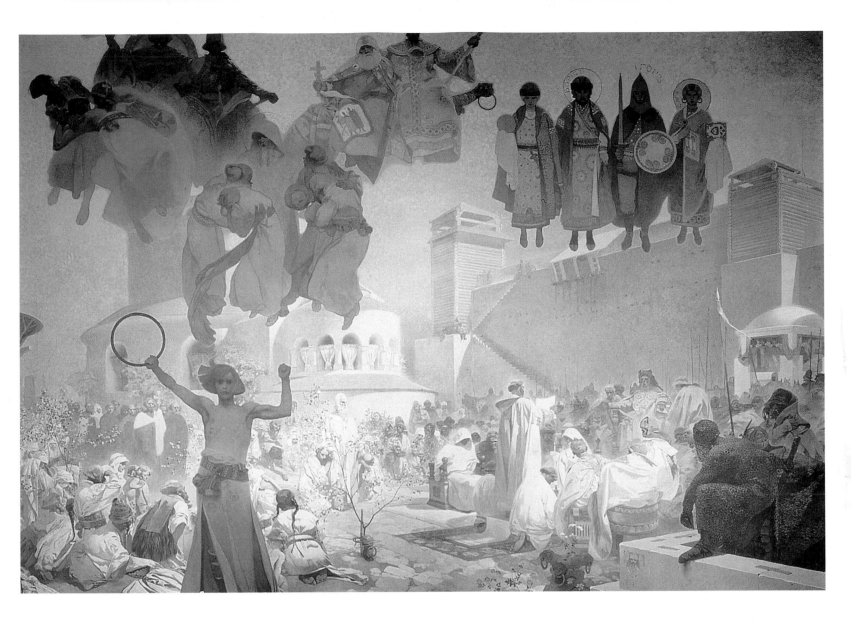

71. *The Introduction of the
Slavonic Liturgy
"Praise God in Thy Native
Tongue"*, 1912.
Distemper on canvas,
810 x 610 cm.
Mucha Museum, Prague.

Mucha's style was a formula that could easily be imitated by lesser talents but with disagreeable results. Mucha contributed to the popularisation and vulgarisation of his style by publishing an illustrated book of decorative designs and motifs entitled "Documents Décoratifs". As he put it somewhat naively, "The enterprising publishers sold the work to schools and libraries of nearly all the countries of Europe, and I think it made some contribution towards bringing aesthetic values into the arts and crafts."

The predictable result was a plague of plagiarism and during the World Exhibition Mucha was obliged to waste a great deal of time rooting out imitations of his work. "My art was en vogue, it penetrated into the factories and workshops as 'le style Mucha' and various items at the Exhibition were continually being seized to protect the original designs against counterfeiting."

By 1906 it must have become abundantly clear to the artist that "le Style Mucha" was passé in fashion-conscious Paris. The year before, the Fauves had exploded upon the Paris art scene at the Salon d'Automne, with a crude and forceful style that must have made Mucha's posters look effete and old-fashioned. The following year Picasso would lay one of the cornerstones of modern art with his revolutionary painting "Les Demoiselles d'Avignon". Cubism was on the horizon and Futurism too with its slogan of "Kill the Moonlight" and its contempt for everything represented by the fin-de-siècle. It was time for Mucha to leave town and he took himself off to America in search of lucrative portrait commissions and teaching posts. Mucha's years in America until shortly before the First World War were professionally and artistically unsatisfactory. The ambition to paint the vast canvases of the Slav Epic was always in the back of his mind. After his definitive return to his homeland in 1913 he devoted the remaining years of his career to this project. Patriotic painting is rarely good painting. Mucha's Slav pictures are not bad paintings – he was always too accomplished for that- but they are curiously lacking in individuality. With an appropriate change of subject matter they could be by any academically trained and patriotic artist from any part of Europe. Ironically, when Mucha designed his Parisian posters he created a thoroughly personal style, that for all its cosmopolitan roots has an unmistakably if indefinably Slavic flavour. Well into the 1920s, though, when required to take up his old métier of designer or illustrator he was capable of reverting to an Art Nouveau style of only slightly diminished curvilinear exuberance. Mucha died in 1939 at the darkest moment in the history of his people. Ahead lay six years of Nazi tyranny and decades of Soviet-controlled communism. Of one thing though, Mucha always remained convinced; that like grass which has been crushed, the indomitable spirit of the Czech people, which has given the world so much beauty, would rise again.

72. *Destiny*, 1920.
Oil on canvas,
53.5 x 51.5 cm.
Mucha Museum,
Prague.

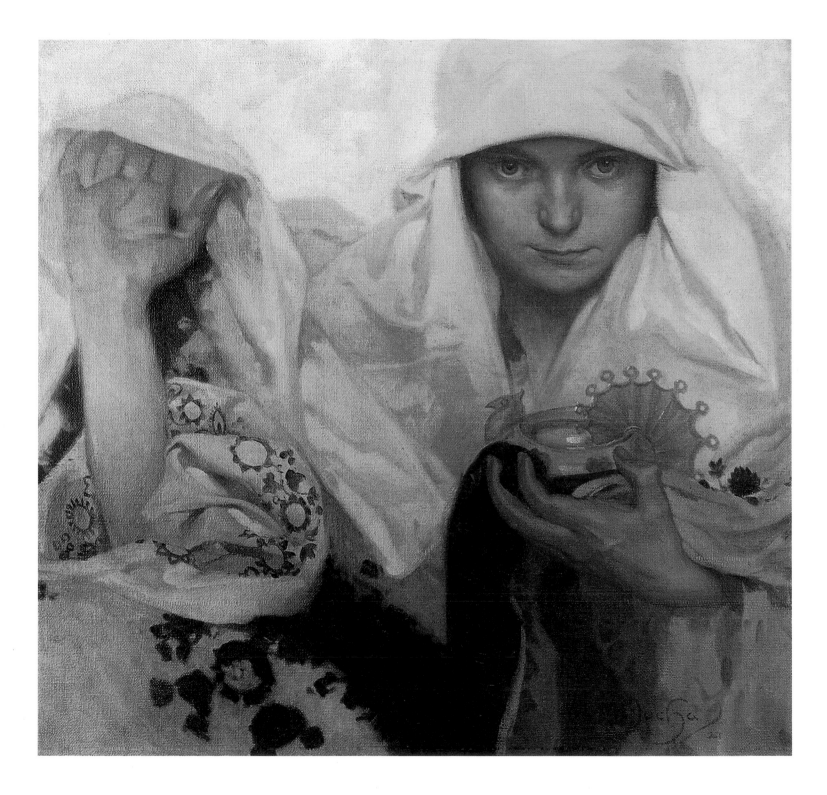

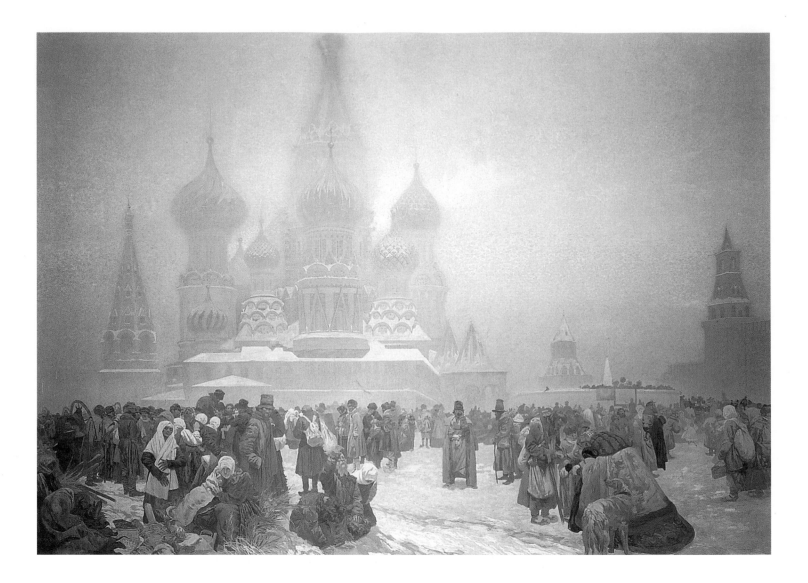

73. *The Abolition of*
 Serfdom in Russia "Free
 Work – Foundation of
 States", 1914
 Distemper on canvas,
 810 x 610 cm. Mucha
 Museum, Prague.

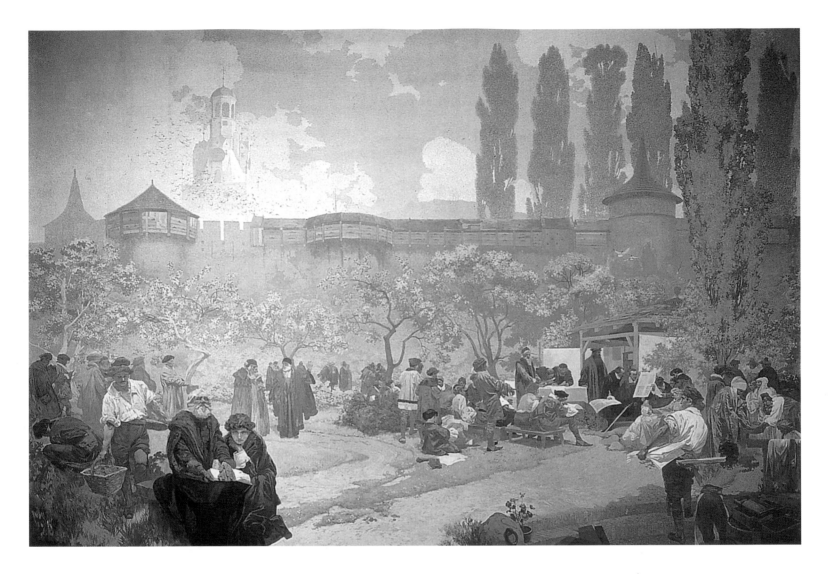

74. *The Printing of the
Kralicka Bible at
Ivancice "God gave us
the Gift of Language"*,
1914. Distemper on
canvas, 810 x 610 cm.
Mucha Museum, Prague.

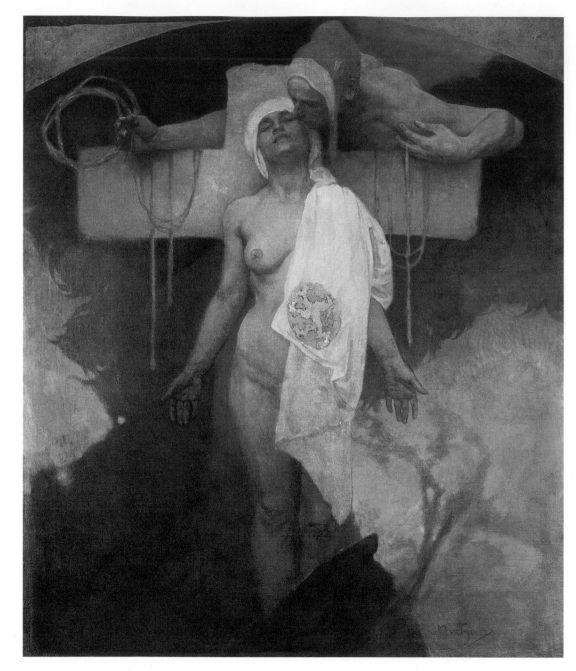

75. *France kissing
 Bohemia*, c. 1918.
 Oil on canvas,
 105 x 122 cm.
 Mucha Museum,
 Prague.

76. *The Apotheosis of the
 Slavs*, 1926.
 Distemper on canvas,
 6 x 8 m.
 Mucha Museum,
 Prague.

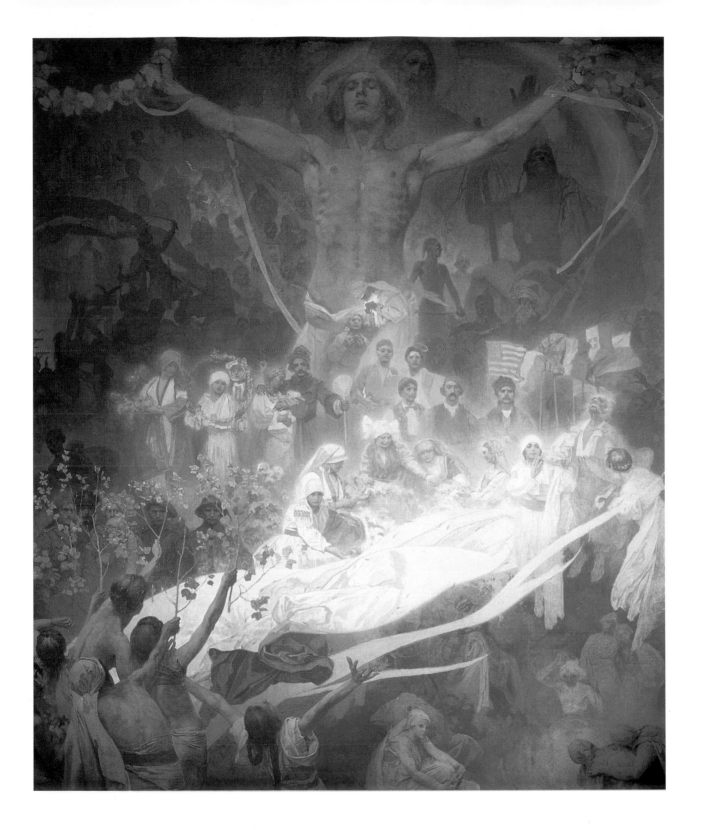

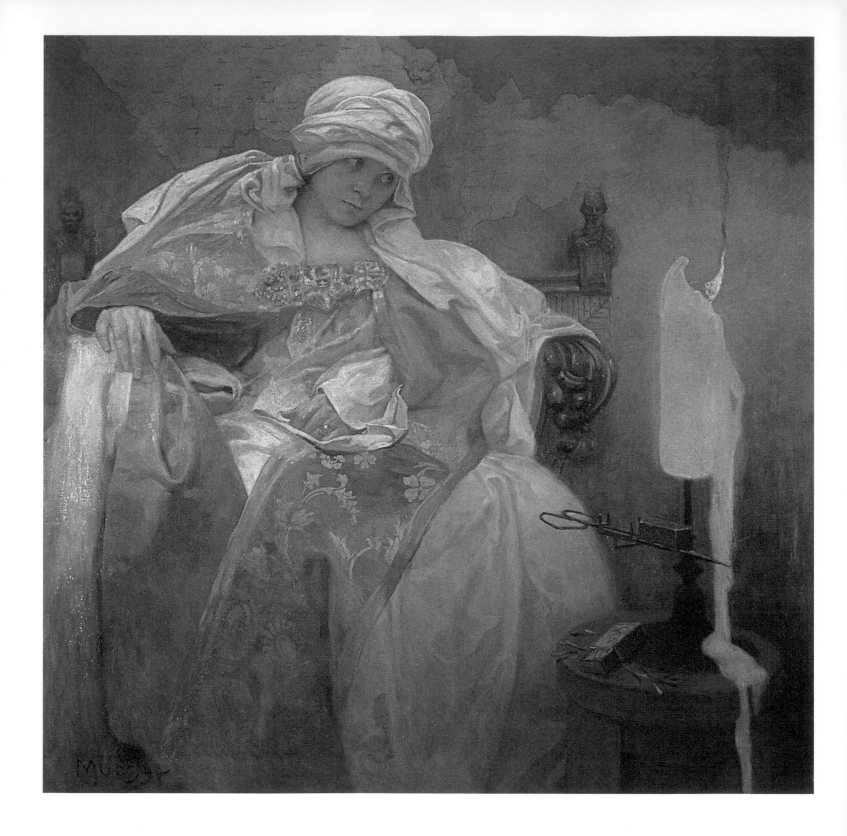

BIOGRAPHY

1860

Alphonse Mucha is born 14ᵗʰ July in Ivanice, Moravia, a province of the Austrian-Hungarian empire. He is the son of a bailiff and is brought up in keeping with the virtues of patriotism. He begins to draw at a young age.

1871

Mucha is a chorister at the Saint-Peter's Cathedral in Brno, where he receives his secondary school education. It is there that he has his first revelation, in front of the richness of baroque art. During the four years of studying there, he forms a friendship with Leos Janáček who will be the great Czech composer of his generation.

1877

He fails to enter the Academy of Art in Prague.

1879

Mucha finds work as an auxiliary in a firm of theatre designers in Vienna.

1881

Following a fire which ravages the Ringtheatre, the main client of the firm where he works, Mucha is dismissed. He settles in the small town of Mikulov where he draws portraits. There he meets his first patron, Count Khuen, who invites him to decorate his castle with painted murals.

1884

Mucha studies art in Munich whilst carrying out work for Count Egon, brother of Count Khuen, in Tyrol.

1888

He moves to Paris, a city excited at the forthcoming Exposition Universelle.

77. *Woman with Burning Candle*, 1933.
Oil on canvas,
79 x 78 cm.
Mucha Museum,
Prague.

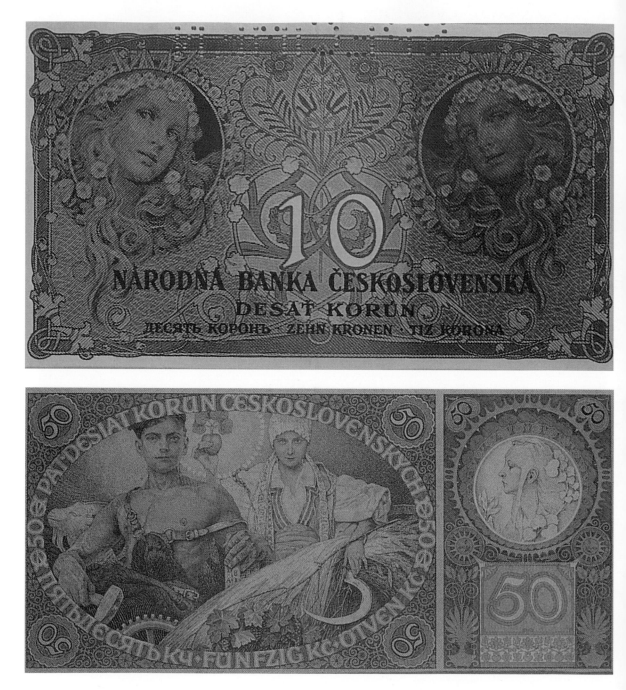

78. 10 Crowns banknote
of the Republic of
Czechoslovakia, 1920.
Banknote,
11.4 x 8.6 cm.
Mucha Museum,
Prague.

79. 50 Crowns banknote
of the Republic of
Czechoslovakia, 1931.
Banknote, 16 x 8 cm.
Mucha Museum,
Prague.

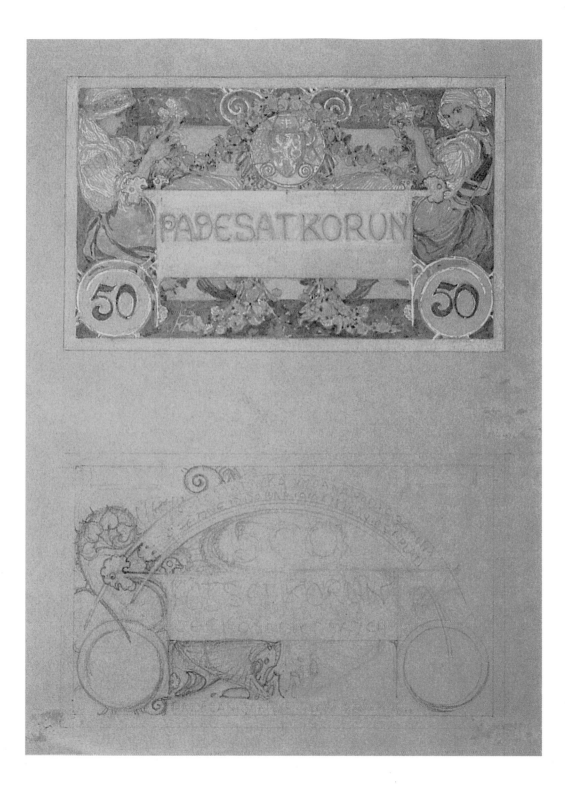

80. Drawing for a 50
Crowns banknote of
the Republic of
Czechoslovakia, 1930.
Charcoal drawing and
white highlights on
paper, 11.6 x 21.5 cm.
Mucha Museum,
Prague.

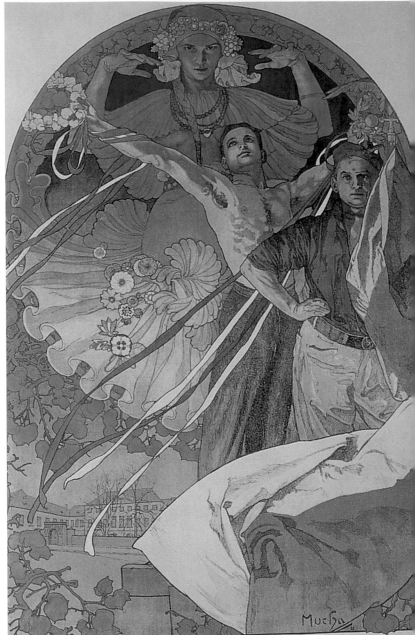